BASEBALL IN
WICHITA

BASEBALL IN WICHITA

Bob Rives

ARCADIA
PUBLISHING

Published by Arcadia Publishing
Charleston, South Carolina

Printed in the United States of America

Library of Congress Catalog Card Number: 2004110240

For all general information contact Arcadia Publishing at:
Telephone 843-853-2070
Fax 843-853-0044
E-mail sales@arcadiapublishing.com
For customer service and orders:
Toll-Free 1-888-313-2665

Visit us on the Internet at www.arcadiapublishing.com

CONTENTS

ACKNOWLEDGMENTS

No book, or article, is the product of one person. In this case, heartfelt thanks go to many who contributed in one way or another. Among them are Mary Nelson, of the Wichita State University Library Special Collections; George Platt, also of WSU; the Wichita State University Sports Information Department; Bill Burdick, at the National Baseball Hall of Fame Library; Jami Frazier Tracy at the Wichita-Sedgwick County Historical Museum; Michelle Enke, local historian at the Wichita Public Library; Steve Shaad, until early 2004 the vice president and general manager of the National Baseball Congress and of Wichita Baseball, Inc.; Matt Rogers, marketing and media relations manager for the NBC and WBI; Mrs. Forrest Jensen Jr.; Norman Glickman; Larry Lester, CEO of NoirTech Research, Inc.; Lisa Ramsberger, the Houston Astros; Melody Yount, the St. Louis Cardinals; Sharon L. Olseon-Womack, Reno County History Museum; Susan Arensman, USD 259; Stuart Osterthun and Rama Peroo, Cowley County Community College; Fred Romanski, National Archives & Records Administration; Barbara Constable and Hazell O. Stitt, Dwight D. Eisenhower Library; Laurie Smigielski, Detroit Tigers; Diane Cotter, Syracuse University Library; Jarrod Rollins, the Cincinnati Reds; the St. Louis Cardinals; the Minnesota Twins, and my son, Tim Rives, also of the NARA, for his editing eye and baseball knowledge.

A number of printed sources proved immensely helpful. These include references in *Kansas History: Baseball in Kansas, 1867–1940* by Harold Evans, in *The Kansas Historical Quarterly,* including the following: *Baseball's Barnum* by Bob Broeg; the research notes of Dr. Edward N. Tihen and Dr. Craig Miner in the Wichita State University Special Collections; *The Baseball Encyclopedia* by Macmillan; *Bush League* by Robert Obojski; *The Texas League Media Guide and Yearbook; The Western League* by W.C. Madden and Patrick J. Stewart; *The American Association* by Bill O'Neal; *The Pitch That Killed* by Mike Sowell; *Jim Crow Strikes Out* by Jason Pendleton; *Sunflower Stars: Big Leaguers from Kansas, In Search of Victory* by Thomas S. Busch. Also of use were: *Claude Hendrix: Scapegoat or the Ninth Man Out?* by George Platt in *The Cooperstown Symposium on Baseball and American Culture, 2001; The National Game* by Alfred H. Spink; *The Minor League Register,* edited by Lloyd Johnson; *Deadball Stars of the National League,* edited by Tom Simon; *Baseball: An Illustrated History* by Geoffrey Ward and Ken Burns; *The Biographical Encyclopedia of the Negro Baseball Leagues* by James A. Riley; *The National Baseball Hall of Fame and Museum Yearbook;* the yearbooks and media guides of the National Baseball Congress, the Wichita Wranglers, and Wichita State University; *The Sporting News;* the files of *The Wichita Beacon; The Wichita Eagle*—particularly its outstanding series on the history of minor league baseball in Wichita—and *The Independence Daily Reporter.*

INTRODUCTION
Baseball Unimportant?

The last time I saw Lefty, he was sitting on our sofa, visiting across the living room with Dad.

The two had been friends for years. Dad, in fact, had often been his catcher. But then, who hadn't? Lefty, whose full name was Claude Alfred Thomas, had earned his living turning catchers' mitts into dust in towns that even road maps later ignored. He pitched in 647 professional games over 16 years, probably that many more as a semipro.

World War II was winding down that night and Lefty was in town on business. He was the top Selective Service System official in Oklahoma, the man with some influence on who was drafted. If your kid was nearing 18, you wanted him on your side.

Dad wasn't worried about my military status. I was 11 and my interest in their talk centered on the couple of post-baseball years Lefty spent as a guard at a federal reformatory near El Reno, Oklahoma. My ears tuned in when he described the "shotgun squad," prisoners who as punishment were told to dig a 6-by-6 foot hole. When finished, they refilled it. I made a mental note to duck if I saw Dad bringing a spade.

But most of the talk, as usual, was about baseball. Dad had played enough that old teammates dropping by was routine. I took them for granted. Lefty, however, was special. His brother was married to Mom's sister, making him part of the family and giving me certain bragging rights among other kids. No one else had an uncle who had played in the major leagues—in Lefty's case with Washington in 1916. My IQ—Insufferability Quotient—went even higher as a result of this discovery, something even close observers had thought nearly impossible.

In many ways, Lefty typified stardom on the slow track of a career minor league player. Of the 300,000 or so who have played minor league baseball, he is one of only 870 named in *The Minor League Register,* a kind of who's who of those who spent most of their careers away from major league glitter. Most of those named played before farm systems radically changed how local teams were organized and forced players into quick retirement if they seemed not to be destined for the top. Thus, Lefty was able to spend half of his 16 seasons in the Western League with Wichita and Des Moines. Known for an indestructible arm, he once pitched 62 games in a season, almost half of those played by his team. Sec Taylor, sports editor of the Des Moines paper, was such a factor in that city's baseball history that its ball park is named for him. When Sec formulated an all-time Western League all star team, he put Lefty on it.

But Lefty's greatest contribution to baseball was as a mentor. It was he who taught Carl Hubbell to throw the screwball. Known in baseball circles as "King Carl," Hubbell attained fame in the 1934 Major League All Star Game by striking out Ruth, Gehrig, Foxx, Simmons and Cronin in order.

In most places he played, Lefty was also the resident wit, with stories woven more or less from the same fabric as those of Will Rogers. With the Nationals he once was asked how he managed to live so well; he explained to a *Washington Post* sportswriter that Oklahoma residents rob more

banks than those of any other state. In truth, if he lived well it was because he supplemented his baseball income: while pitching at Los Angeles he also sold Paige automobiles.

Lefty was the key figure in a transaction with long-lasting implications for baseball in Wichita. During World War I, the minors suspended operations while he and other players were fighting in France. When he returned in 1919, *The Wichita Eagle* called him a "genuine war hero" and he made the Frank Isbell-owned Wichita Witches as a pitcher and fill-in outfielder. However, Isbell had a problem. An outfielder was hospitalized after being hit by a pitch and he needed help. When Isbell learned that Kansas native Joe Wilhoit and pitcher Art Bowman were available from the Pacific Coast League, he traded them for Lefty. For Wilhoit, who had played for the New York Giants the previous year, it was another drop in a sagging career; but once in Wichita, his strangely silent bat began speaking—nay, shouting—and he set a professional baseball record by hitting safely in 69 successive games, a mark that still lived into the 2004 season. That streak and a .422 batting average earned him the title of Minor League Player of the Decade from *Baseball America*. Only Joe DiMaggio, once in the minors and again in the majors, seriously challenged Wilhoit's streak. For Lefty, the trade was a long-lasting promotion to a higher classified league.

Some say, of course, "So what?" Wilhoit set his record on the small stage of a mid-level minor league. Lefty spent most of his career in what many term "the bushes." What's often forgotten is how good a player must be to perform well in the minor leagues. Here's a great example: as 2004 football training camps prepared to open, the Dallas Cowboys had three quarterbacks—Drew Henson, Quincy Carter, and Chad Hutchinson—all of whom had played minor league baseball without making a dent in the majors. (Carter had one hit in eight times at bat in the big leagues and Hutchinson pitched four innings.) If Lefty was anything, he personified the guy who gave the game everything he had for as long as he could—and reveled in it. He typified many who brought baseball to the Wichitas of the world.

Outstanding athletes are not limited to the professional leagues. Baseball in Wichita and the surrounding area achieves a different balance in the public eye than does baseball in many other communities. In many cities, the professional team, regardless of classification, is *the* team. As important as professionals have been in Wichita, semipro and college baseball have had at least equal presence.

Raymond Dumont, called "Hap" for happy, failed as a stand-up comic. But in 1935 he founded the National Semipro Baseball Congress, which later dropped the word semipro. NBC participants form a mini-hall of fame—from Joe Tinker to Fred Clarke to Satchel Paige to Tom Seaver. The only three players to hit 70 or more homeruns in a professional season all played in the NBC—Joe Bauman, Mark McGwire, and Barry Bonds. More than 300 alumni have played in the major leagues.

And for nearly three decades, Wichita State University's Wheatshockers, under the direction of Gene Stephenson, have been a premier college team. By the start of the 2004 baseball season, 42 Shockers had become all-Americans and 27 had played in the major leagues. Early in 2004, Coach Stephenson won his 1,428th collegiate game, the second most ever by a college coach.

Still, most of those who played or enjoyed baseball in Wichita are not members of a Hall of Fame or ever earned a living from the game. They were fathers and sons, men who as boys or later in life played for sheer joy. Or, they were moms and daughters, some of whom were better than their men. These fans built towns, made laws, defended the nation, and did countless other tasks while keeping an eye, and sometimes a foot, on the diamond.

Some may have a problem keeping their sports passion "in perspective." American art historian Kirk Vanedoe, who played football in college and briefly worked as an assistant coach, talked about his abbreviated coaching career with *New Yorker* writer Adam Gopnik in the May 10, 2004 edition of the magazine: "You have to be smart enough to do it well, but dumb enough to think it is important."

Bill James, a true baseball authority and also a Kansan, applied similar logic to baseball in an article by Tim Rives in the April/May 2004 issue of *The American Enterprise*. James said, ". . . baseball is inherently meaningless. . . ."

Sports? Inherently meaningless or unimportant? Not really. When baseball was introduced into the prison system early in the 20th century, Leavenworth warden R.W. McClaughry offered a better summation: "Baseball takes the mind of the prisoner off his troubles, stimulates him to better efforts and . . . is one of the best diversions available."

Walt Mason, in *The Emporia Gazette* in 1911, may have captured the real truth. He said, "The man who doesn't feel during the baseball season that the game is the most important thing in the world deserves considerable sympathy. The true fan prefers high class baseball to an inferior article, but if he can't see the better grades, he is willing and anxious to see the cheaper article. When everything else fails he will sit on a barb wire fence for hours at a time to see the school boys running up a forty-eight to thirty score."

And so it is for most fans. Life contains enough sweat, dirt and, occasionally, tears that diversion is, at times, useful. It is to those who have played, watched, and dreamed about baseball that this book is directed. It is not a complete history of the game in the Wichita area—very broadly defined for this book, reaching out in all directions to cover the heart of Kansas. Instead it offers images to help honor a few who played and the many who watched, to rekindle old dreams, or to spark new ones. To the extent it does any of these, it succeeds.

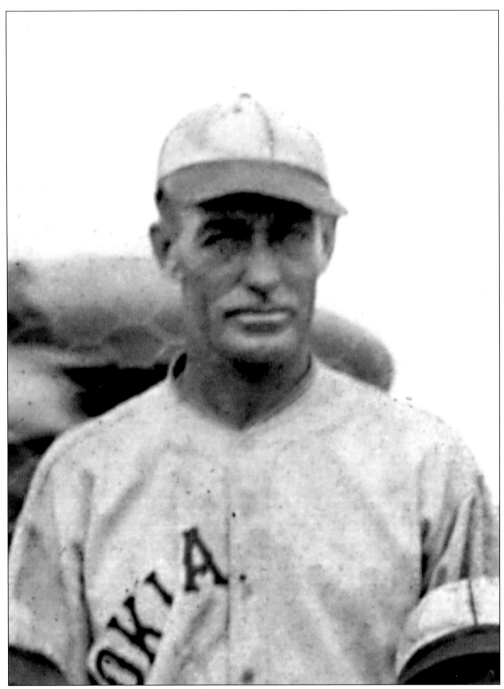

Claude "Lefty" Thomas spent half of his 16-year professional career pitching in the Western League at Wichita and Des Moines. So effective was he that Des Moines sports editor Sec Taylor named him to his all-time Western League all star team. But Lefty's biggest contribution to baseball was as a teacher. He is credited with having taught Hall of Fame pitcher Carl Hubbell to throw the screwball. Thomas interrupted his long minor league stint only twice—once to pitch briefly for the Washington Nationals and again to serve in France in WW I.

ONE

Wichita Baseball Had Little to Hyde

Long before recycling became a buzzword, Alfred A. Hyde was making a living off the leftover fat of the land—at least of the land of Wichita.

Hyde came to Wichita as a banker in 1871. Soon he discovered that tallow from the city's growing meat packing business could cure almost anything if rubbed on the human body—or perhaps at least achieve a powerful placebo effect. Jelled and menthol-laced, the pungent fat was christened Mentholatum. By 1915 some were claiming the salve could cure diseases ranging from piles to pneumonia. All that drew a stern warning from a skeptical federal government which was starting to crack down on spurious patent medicine assertions. Still, Hyde's name is well-remembered in the city he rid of tallow—a park near the old Mentholatum plant, a YMCA camp, and an elementary school all bear his name.

But Hyde did something besides bottle and sell fat. On January 29, 1867, he helped incorporate the first formally organized baseball team in Kansas, the Frontier Baseball Club at Leavenworth, where he was working in a bank. Hyde was not lead man. That was a Civil War veteran, Colonel Thomas Moonlight. But the young banker's signature was there, and he was part of bringing the growing sport to Kansas, appropriately to its oldest city. By year's end, the game gained more status as the Kansas State Fair began awarding a silver baseball to the state's best team. Exactly when baseball moved west to Wichita is less certain. Like sunflowers, the game just seemed to spring up there, and Hyde was apparently too late or too busy to have a part in it.

In fact, baseball isn't much older than Wichita. Never mind the stories about Abner Doubleday and the fields at Cooperstown, New York. It was Alexander Cartwright who in 1845 codified the rules and is as close as anyone to being a "father" of the sport. Among other things, he set the three-strike rule as a way to put out a player and limited a team to three outs each time at bat.

Cartwright's love-child probably arrived in the Wichita area with soldiers or with new veterans of the Civil War. Until that conflict, the game had been largely confined to the Northeast, particularly New York City where Cartwright lived. In 1860 only 61 teams were members of the National Association of Base Ball Players, although there were other clubs. Soldiers from both North and South became a sort of sporting missionary society, playing where they fought, at times against each other as prisoners-of-war squared off against guards. When the war ended, the game's exploding growth replaced the sound of cannons.

Wichita officially became a city in 1870 after 123 men and one woman—Catherine McCoy, the mother of Billy the Kid—signed the incorporation papers. Baseball wasn't far behind. In 1874 the two-year-old *Wichita Beacon* noted: "The baseball mania has reached us. What with the Indian scare, the drought, the clinch bugs and the grasshopper, truly we are badly afflicted; but as a supplement to this grand drama of misery, our callow youths have inaugurated the 'National Game' in the midst of us—what shall we do to circumvent their initiations?"

The team wore "bluff bladder skin caps" and "flashy shirts, white breeches, blue stockings," and "yaller" hob-nailed pumps. "A stranger happening among us on field day would the think the state penitentiary was located here," the *Beacon* said. In September another Wichita paper, *The Eagle*, reported a group of "colored boys" had begun baseball practice on a field north of town. This is the first known local mention of scarcely-covered black baseball in the 19th century.

It's doubtful if men in "flashy shirts" really startled most Wichitans of the 1870s. It was a cowtown, the end of the Chisholm Trail. The goal of most dust-covered young men who arrived with their thousands of bawling cattle was to spend the $30 a month they'd earned on the ride north on fun. Often that meant a stop in the saloon-lined red light district on the west side of the Arkansas River. But some cowboys also splashed across, looking for different excitements—including baseball. Some of them played at a diamond at what became 2nd and Main Streets, site of the city's tallest building, the Epic Center; others played farther east at Mathewson's Pasture, not far from the Mentholatum plant.

In 1875, still a year before Little Big Horn, *The Eagle* reported on baseball: "In the east the interest in the game is like a furor. The spark has even reached as far west as Wichita and our young men are actively engaged in organizing a good club…Last Saturday nine young men from El Paso [now Derby] and vicinity, supposed to be the bone and sinew of the base ball club, without any previous warning, dashed into our quiet metropolis, and very much after the manner of lions, coursed through our streets seeking not whom they might devour, exactly, but with considerable assurance inquiring on every hand whether or not there was anybody in Wichita who played base ball."

Apparently there was. "Some of our young men who used to play ball a few years ago began to emerge from their places of concealment and, after some delay, got together and made up a nine." Before what the paper called "quite a crowd," Wichita in seven innings won "five to fifty-two." The paper went on, "The victory pleased the boys exceedingly and has encouraged them to organize a club." Unfortunately, the sport took at least one bad turn. Within weeks, 15-year-old Johnny Chapman fractured the skull of Frank Lants with a bat during a game near the depot. Presumably Frank lived. He had regained his speech the next day and his death was not reported.

By 1879, the *Eagle* put its editorial tongue in cheek and announced, "[B]aseball can neither be considered a pastime or amusement…Last Friday seven lame doctors and nearly the same number of lame and crippled lawyers were hobbling about their business from the effects of too much baseball in the game between the doctors and the lawyers. The game is altogether too violent for inexperienced players, and to be able to play a good game or any game easily the club must devote their whole time to the game, in which case it is a business and no pastime at all."

The paper did say that organized physical activity was needed in Wichita, editorializing that "the English have better physiques than Americans" because of their love of sports. The *Eagle* went on to complain that it takes money to support a good baseball team and that a poor team is "worse than none at all."

Apparently, Wichita fans found some money. In 1885, Wichita hosted the Arkansas City Borders in a game played for a $100 prize.

On July 28, 1885, *The Eagle* said:

> The best and closest contested game of the season came off at Carey's park yesterday between the Wichitas and the Arkansas City Borders. The two clubs are the boss nines of southern Kansas, and at the contest yesterday every inch was played for by the most skilled playing ever seen in this city. A very large and enthusiastic audience of the lovers of the game were present and cheered lustily throughout the game. The game was for $100 which the Wichitas pocketed, the game standing 18 for the Wichitas and 17 for the Borders. N. Jitty, one of the Wichitas, met a swift ball and was rendered de hors for a few moments, but played the game throughout.

Bat boy for Arkansas City that day was W.T. Kimmell who returned to Wichita as owner-manager of its 1905–06 Western Association professional team, the first paid team for the city since 1887. Colorful and stubborn, Kimmell once fenced off part of the ball park's outfield in a dispute with the club over land ownership. The briefly unconscious Norman Jitty would umpire the first exhibition game played by Kimmell's team in its new South Main street stadium.

Although the 18-17 score in the Wichita-Arkansas City game seems high by 21st century standards, the sport's early rules favored the batter. In that game, for example, a pitcher had to finish any inning he started. The exception was if the pitcher was injured. That meant a bad pitching performance sometimes resulted in catchers or infielders aiming a ball at a failing pitcher's head, truly knocking him out of the game.

By 1892 the city had formally organized a baseball association. J.T. Dorsey was president; Doctor Hougland, vice president; Brent Maret, assistant manager and secretary; Charles Mossbacher, treasurer; and George P. Locke, general manager.

The purpose was to "organize a base ball nine that will be as good as any in the west," the *Eagle* noted. It planned to play in Riverside Park but actually opened at the fairgrounds.

As popular as the game was becoming, limits were being drawn. In 1898 a group led by a former professional player turned Methodist minister, the Reverand R.T. Savin, asked for a Sunday baseball ban. While the city council voted 7-4 against the proposal, it did prohibit locating a ball park within 300 feet of a residence without permission of the owner.

Even though Savin and his parishioners were unable to stop Sunday play in Wichita, others were more successful in Topeka. State law by 1907 made "horseracing, cockfighting or playing cards or games of any kind on Sunday" a misdemeanor. In July of that year, Ernest Prather was arrested in Johnson County for violating that law by promoting a baseball game. But his conviction in district court was reversed by the Supreme Court of Kansas. Justice Silas Porter noted, "This construction would make the statute apply to every game—to authors, whist, chess, checkers, backgammon and cribbage, even when played within the privacy of one's home, and to croquet, basketball, tennis and golf whether played in public or on private grounds." However, the state did ban baseball on Memorial Day.

Legislation failed to stop all moral problems with the game. As late as 1917, R.G. Boylen and Charles Keifner were each fined $10 plus court costs of $2.92 in Wichita city court for betting on baseball.

Since its arrival in the city baseball has enjoyed a long and colorful life. There have been ups and downs for teams, attendance, and fans, generally following the national trends of wars, depressions, television viewership, and changing tastes. But the climate has been positive for professional, amateur, school, and semiprofessional organizations in this past century-and-a-third as the game has entertained Wichita and the area around it.

With the 21st century underway, the sport maintains a lively pulse in the Texas League Wranglers, a high profile collegiate presence at Wichita State University, and the National Baseball Congress nears its 70th birthday.

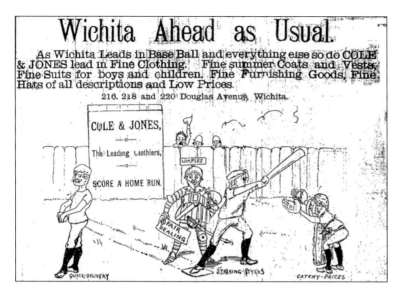

This 1887 newspaper ad for Cole & Jones probably is the earliest depiction of baseball in Wichita. It also suggests a "missing link" between cricket and baseball, a tie sometimes avoided by baseball historians, some of whom believe the American game evolved separately. But in this drawing, the catcher is wearing the kind of gloves worn by cricket players, and the pitcher's stance suggests that of a cricket bowler who makes a half-turn before running toward the player and bouncing the ball for him to try to hit. Largely confined to the Northeast before the Civil War, baseball grew rapidly when peace was restored. In Kansas, as in many places, the first team to be chartered (in Leavenworth in 1866) was due to the initiative of a Civil War veteran. Future Wichitan A.A. Hyde, a young bank clerk, was one of those who signed the incorporation papers. The exact date the game was first played in Wichita is unknown, but by the time the city was incorporated in 1870 games were taking place.

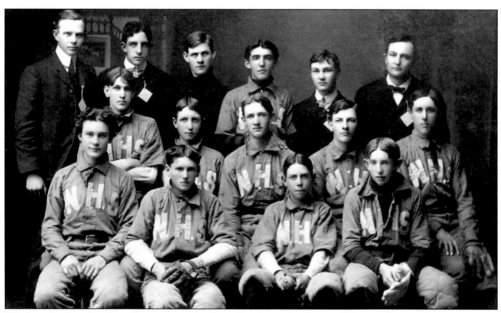

Wichita high school students sported a big WHS on the front of the uniforms they wore with obvious pride. In 1919, the high school team played evenly against Fairmount University, now Wichita State, before losing 2-1. The game was the only one played by Fairmount that year, giving it a perfect record for the season. In addition to schools, other boys groups also had teams. (Photo courtesy Wichita Public Library.)

By the turn of the 20th century, baseball was well-established in Wichita. Three times the city had been represented by teams playing short professional seasons, and would be again in 1905 when the city joined the Western Association. Almost from the start, men and boys were playing throughout the city, sometimes against each other and often against teams from neighboring towns. In one game, a team from Derby—called El Paso then—rode unannounced into town and asked if anyone played. According to newspaper accounts, someone rounded up the Wichitans who went on to win 52-5 over the interlopers. Professional teams, including the Kansas City Blues and Cincinnati Reds, were scheduled for games in Wichita, and collegiate baseball was already beginning. In this picture, the team seems to have lost, guessing by the looks on many players' faces. (Photo courtesy Wichita Public Library.)

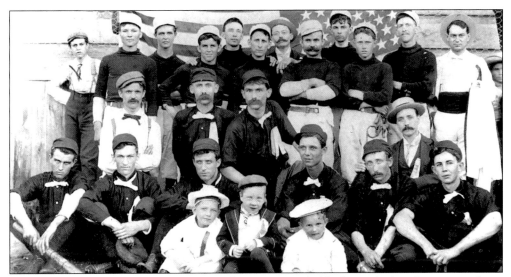

The City League was formed in 1908. But these teams probably date to before that time, judging by the 45-star flag behind them. That design became obsolete in 1906 when Oklahoma was admitted to the union. These two teams may have played as part of a Fourth of July celebration before posing. Pick-up games were common for players of all ages. In one story, *The Wichita Eagle* told of a game between the city's lawyers and physicians that left most of both teams limping. (Photo courtesy Wichita Public Library.)

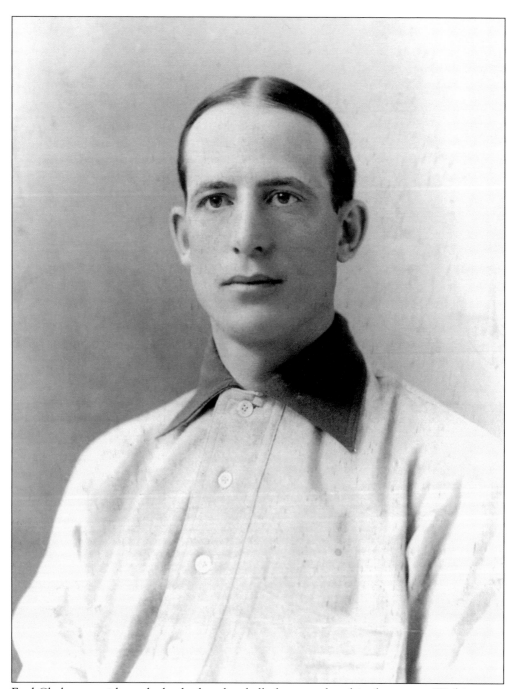

Fred Clarke was without doubt the best baseball player produced in the greater Wichita area. Born in Iowa, he moved with his family to Cowley County before he started school and he owned and lived on a ranch there as an adult. Clarke played 21 major league seasons, finishing with a lifetime batting average of .315; and he managed for 15 years, including during the first World Series ever played. In 1945 Clarke was elected to the National Baseball Hall of Fame. (Photo courtesy National Baseball Hall of Fame Library.)

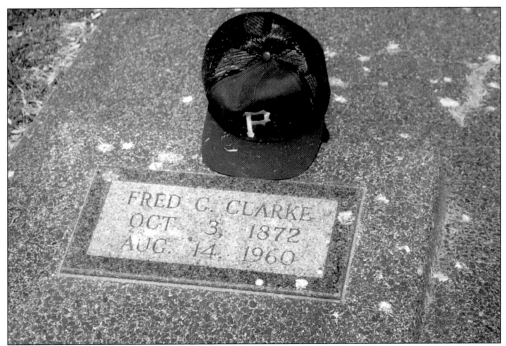

Buried beside his wife in a small cemetery in Winfield, Clarke has been at rest since 1960...But fans don't forget. An admirer keeps a Pirates hat at the grave. Clarke first played for Louisville in the National League, but the team was combined with Pittsburgh's in 1900. Among stars he managed were fellow Hall of Fame members Honus Wagner and Rube Waddell. Clarke's younger brother, Josh, born near Winfield, was also a major league player—the first born in the Wichita area to arrive at that level.

Early Wichita baseball teams played where they could, including the future site of the Epic Center at 2nd at Main Streets, the fairgrounds, city parks, and Mathewson's pasture east of the downtown. But by the early 20th century, Association Park was built for the new Western Association team, the Jabbers. The first section of the stadium was built at a cost of $1,500 and dedicated in 1905. Located in the 1000 block of South Main, at the end of the streetcar line, the park was financed by gamblers, not investors. Chances on a new car were sold to pay for it. (Photo courtesy Wichita Sedgwick County Historical Museum.)

Turn-of-the-century American baseball had far more in common with the pool hall than the drawing room. Baseball had a rough-and-tumble image closely aligned with beer and cigar smoke, with sliding hard with spikes high, and with post-game brawls. Umpire Brick Owen, a Kansas native, once had to escape the wrath of a Wichita crowd by fleeing over the centerfield fence after calling a local player out at second base. This Wichita team, name and players long forgotten, is typical of many in the early 20th century. Note the cigar clenched in the teeth of the player in the white hat in the front row. Was he smoking it while the game was in progress? (Photo courtesy of Wichita Public Library.)

Two

The Cowley County Rancher and the World Series

When Fred Clarke died in a Winfield hospital at age 87 in 1960, he had been a rancher for more than half his life. But to baseball fans he was much more. Clarke was the most successful and probably best player to come from south central Kansas; one of the best from anyplace, in fact. Alfred H. Spink, founder of *The Sporting News*, for many years known as the "bible" of baseball, called him "one of the greatest base ball players who ever lived." By 1945 the Kansas rancher was in the National Baseball Hall of Fame.

Clarke's most enduring legacy may be the World Series. He played and managed in the first series ever, with Pittsburgh, and is credited by some for helping start the fall classic. The National League had been around more than a quarter century by 1903 and the American League was just in its third season. The newcomers persuaded the established league to have a "world championship" series, but to the senior league's embarrassment, the American League won. So red was the National League's face that it refused to play again in 1904. In 1905, though, the lure of money managed to overcome the agony of the first defeat and the classic tradition resumed. Clarke, though, was unscathed by his team's loss to the Red Sox in the first Series. He was already a veteran. In 1909 he led his Pirates to the title, earning a .500 record as a World Series manager.

Born in Iowa in 1872, Clarke moved with his family to Cowley County before starting school. There, his younger brother, Josh, was born. By 1898, at age 19, Josh became the first person born in the greater Wichita area to play in the major leagues. He joined the Louisville Colonels, then of the National League, where big brother Fred was manager. Josh also played with St. Louis, Cleveland, and Boston before retiring in 1911.

Fred was really the family star though, and his destiny seemed assured from the beginning. Just two years after starting his professional career at Hastings, Nebraska, in 1892, he arrived in Louisville and hit four singles and a triple in his first five times at bat. His batting average that first season was .406.

In 1900, the National League contracted from 12 teams to 8 and Clarke's Colonels merged with Pittsburgh, where he contributed as manager as well as outfielder. It was that team, which also boasted Hall-of-Famers Hans Wagner and Rube Waddell, that Clarke led into the 1903 World Series. For 21 seasons Clarke played major league baseball, and in 15 he also managed. As a player he hit .312, and as manager won four National League pennants and a world championship.

Clarke was not the only player from the region to become a big league manager. Salina native Gene Mauch had a nine-year major league playing career before becoming a manager for a quarter century. He managed the Phillies, the Expos, and the Twins before joining the California Angels for six years, winning division championships in 1982 and 1986.

Wichita player Frank Isbell also made a mark on the World Series. A second baseman not known as an outstanding hitter, Isbell batted .308 in the 1906 World Series, the highest of any

player, as his White Sox defeated the cross-town Chicago Cubs. But his greatest moment in that series was when he doubled four times in one game, a record that, as of 2003, still stood. Less memorable was Isbell's second record—for the most errors, with five. From shortly after the start of the 20th century, Wichitans wanted him to manage local professional teams. A plumber by trade, Isbell eventually became owner and manager of Wichita's minor league baseball teams, modifying his own name and calling them the Izzies. Ultimately, he became a Sedgwick County Commissioner, dying in office in 1941.

No player with ties to south central Kansas had a more unusual career than Charles "Victory" Faust of Marion. More mascot than moundsman, and considered emotionally unstable, he appears as a pitcher in baseball records, shutting out the last-place Brooklyn Dodgers for two innings. At bat, he was hit by a pitch, stole second and third, and then scored. When it ended he asked the crowd, "Who's loony now?" He was cheerleader, clown, good luck piece, and a strange addition to the diamond for the New York Giants as he had reported for duty, uninvited, after a session with a fortune teller.

Stranger still is the fact that Victory's career was made possible with the permission of John J. McGraw, the Giants manager whose reputation for compassion generally compares with that of Atilla the Hun. McGraw wrote, "I give Charlie Faust credit for winning the pennant for me" in 1911. Unfortunately, Victory was admitted to a mental hospital where he died in 1915. The Giants finished last that year.

Carl Mays was both one of the finest pitchers in baseball and among the least liked. He came to be hated after one of his pitches killed one of the game's most popular performers. In 1919 Mays hit and killed Cleveland's Ray Chapman, the only major league player to die as a result of an on-field mishap.

A native of Kentucky and son of an itinerant Methodist minister, the young Mays migrated to Mulvane in 1908 where he pitched a summer for the town team. Mays threw with a tricky underhand motion, eventually winning 207 major league games in 15 seasons with the Red Sox, the Yankees, the Reds and the Giants. He also won three World Series games.

One of Wichita's links to baseball's destiny occurred because of technology rather than hitting or pitching. City players and teams helped make night baseball a reality. In 1929, Ron Vance was pitching for semipro teams in Wichita (at least once for a girls' team). By April 1930, the 19-year-old made history with the first pitch of his professional career. A member of the Independence Producers of the Western Association, his was the first pitch ever thrown as part of a regularly scheduled night game in organized baseball. (Monk Edwards, who became one of Wichita's best-known high school coaches, was a member of that team but reported after the first night game.)

The relic of another first, also on that diamond, Independence manager Marty Purtell had piloted a number of Kansas teams, including Hutchinson's Wheatshockers. (He was past 40 years of age but still playing shortstop when Vance started his career.) The Independence manager had been the first batter to face Babe Ruth when Ruth began his pitching career with Baltimore in the International League.

Independence and Des Moines, Iowa, had been locked in what apparently was an unplanned race to be the first to use electric lights. Des Moines owner E. Lee Kyser had announced at winter meetings that he would install the first lighting system for the 1930 season. But Independence beat him by opening the season at home while Des Moines was on the road.

Ironically, the Wichita Aviators were Des Moines' Western League opponent for the first night game in Iowa, which attracted more than 12,000 fans and a host of baseball luminaries. The crowd saw Woody Jensen become the first Wichita player to hit under the lights. While Wichita lost the game, as well as its chance to be a part of the first lighted game, there was nevertheless a pioneering aspect to the event. Part of the game was the first to be carried on a nationwide radio broadcast. A network of 60 stations aired the game after the fourth inning.

While fans in both Independence and Des Moines said they liked the night games, not everyone agreed. Perhaps still tired from having to stay up to get results, *The Wichita Eagle's* Pete

Lightner declared it was a fad that would pass. But by the end of the year, most of the nation's minor league parks had lights, making ballpark lighting one of the few growth industries in an otherwise deeply dark national depression. *The Official Encyclopedia of Baseball* says lights saved the minor leagues from the Great Depression. In 1935 Cincinnati became the first major league team to install lights.

Even though Wichita had a hand in both of the first lighted games, Island Park, home of the Aviators, was the last in the Western League to be lighted. In 1932 the team played its opener under the lights, beating Pueblo by scoring 17 runs in the fifth inning, just one short of a record for organized baseball and still the standard for the Western League. Chuck Hostetler, Wichita center fielder, tripled twice and doubled in that inning to set an all-time league record. He had five hits in five tries that night, all for extra bases, batted in eight runs, and scored five.

Although new to regular season professional use, lighted games were far from untried. In 1906, a team of Sioux Indians played in Wichita, bringing a generator and lighting system on a rail car; the team played on temporary diamonds next to its rail-mounted equipment. But the game in Wichita took place during daylight since the team did not schedule night games before June and its Wichita appearance was in May. It was too cold earlier in the season, the team said.

In 1930 the Kansas City Monarchs did bring portable lights to Wichita for the first night game in the city. Some 3,000 turned out to Island Park to see the Monarchs defeat the Pepper Barry All Pros 12-5. The evening got off to a slow start when Kansas City had trouble getting the lighting equipment in place and hanging white canvas over the outfield signs to kill the glare. The two teams repeated the match-up a second nigh,t with that game starting on time at 8:05 p.m. The truck-mounted generator and lights had been scheduled for the first use that year for April for a game in Arkansas City, a few days before Independence turned on its lights. But rain fell on Ark City and the Monarchs' night opener was moved to Oklahoma.

The most spectacular end to a baseball career belonged to a plagued former Wichita infielder, Dannie Claire. He played with Wichita on the 1911 team that moved to Pueblo, Colorado in mid-season. Bringing his girlfriend back from Colorado after the season, Claire was among hundreds of men caught during enforcement of the then new Mann Ac,t which prohibited taking women across state lines for immoral purposes.

Claire was sent to the federal penitentiary at Leavenworth for three years where he starred for the White Sox, the prison's varsity baseball team. He returned to Des Moines in the Western League after his release, and then went to Michigan and played for a semipro team. Needing tires for his car, he visited a salvage yard, leaned against a junked Studebaker, lit a cigarette, and died in a fireball when fuel exploded in the car's tank.

Another Wichitan also found himself at Leavenworth but for far different reasons. Earl Browder was a native of west Wichita who twice was Communist Party candidate for the U.S. presidency. Although he was frail as a child and unable to compete in sports, he was sent to prison twice during WW I for refusing to register for the draft. At Leavenworth Browder became manager of a baseball team comprised of players from the print shop and band. He later was charged with passport fraud and sent to the federal penitentiary in Atlanta, but President Roosevelt pardoned him in 1941. During WW II Browder worked for greater cooperation between the U.S. and U.S.S.R. When Russia repudiated that policy, Joseph Stalin stripped him of his party membership and offices.

Dr. Vernon Smith, another Wichita native, has a baseball background that did not involve jail time. Doctor Smith grew up in west Wichita, pitching junior American Legion baseball in the 1930s and watching games at Lawrence Stadium, favoring teams like Wichita Water and Eason Oilers. After graduating from North High School and attending Friends University, he went on to an academic career and won the 2002 Nobel Prize for Economics.

Undoubtedly the best known Kansan of all was Dwight D. Eisenhower, who commanded Allied forces in Europe during WW II and then became a two-term president of the United States. At Abilene High School, the president was a baseball player and, even more, a fan. On

the 80th birthday of Honus (Hans) Wagner, a teammate of Fred Clarke's on the Pirates, the president wrote a letter expressing his admiration for the man called "the Flying Dutchman."

Some historians credit Eisenhower with wanting to emulate Wagner's career. He's quoted as saying that he and a boyhood friend were talking about their futures when the friend said he wanted to be president of the United States. Eisenhower, however, said he wanted to play baseball like Wagner. "Neither of us got our wish," Ike later pointed out.

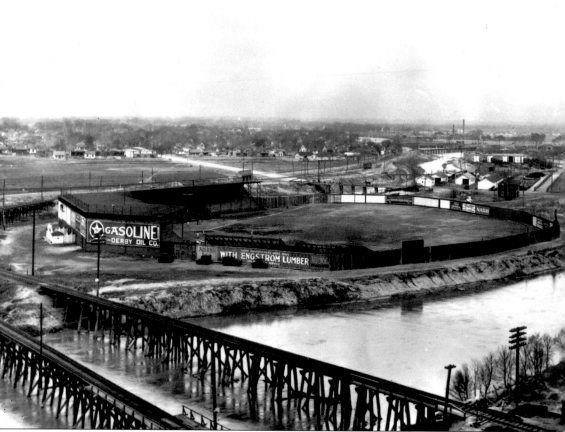

Ackerman Island was a bed of sand in the Arkansas River beside downtown Wichita. In addition to the ball park, the island included an amusement park, known as Wonderland, and served as a recreation center for much of the city. But a discarded cigarette started a fire that destroyed the stadium in 1933 just after the last games of the season. The island stadium was replaced by Lawrence, later Lawrence Dumont Stadium, downstream from the island. (Photo courtesy Wichita Public Library.)

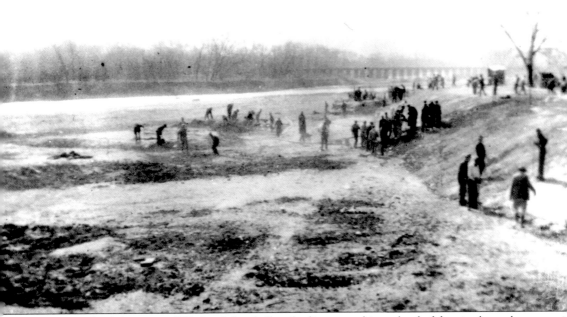

Ackerman Island, location of Wichita's baseball park, disappeared in a cloud of dust in the early 1930s. The channel forming the island in the Arkansas River was filled as part of a Works Progress Administration project and today is the site of 2nd and Seneca Streets. Work was done with hand shovels and wheelbarrows to create jobs for the hundreds of out-of-work Wichitans who lined up each morning, hoping to earn a dollar that day. (Photo courtesy Wichita Public Library.)

Wichita was abandoned by professional baseball in 1933 when its Western League team moved to Muskogee, Oklahoma. There it found the Depression-induced lack of ticket sales equally bad, and it spent the rest of the season on the road, operated by the league. Seeing the city without baseball, Raymond Dumont vowed to start a national semipro baseball tournament if a new park were built. It was and he did. Later the stadium was given his name as well as that of Robert Lawrence, an early mayor.

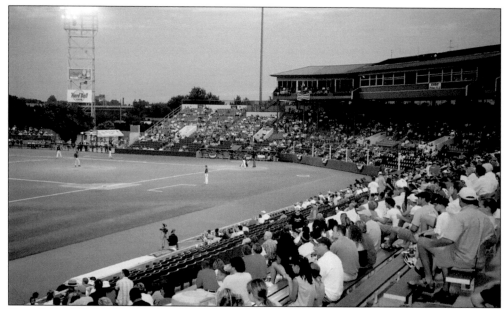

One of the oldest parks still in use by a professional baseball team—it celebrates its 70th birthday in 2005—Lawrence-Dumont is really a new stadium, having seen extensive renovation over the years, most recently in 2001. Crowds approaching 14,000 have attended games in the park, but capacity now is about half that as a result of the changes. There are sky boxes as well as an outdoor restaurant, and a park-like walk around the outfield fence where there are monuments depicting the city's baseball history.

Downtown Wichita rises over the outfield walls at L-D Stadium where colorful banners flutter above the fielder's head. The "20" on the clock in the center of the picture is part of a clock used by the National Baseball Congress to limit the time between pitches and innings, an innovation of founder Ray Dumont. The stadium is home to both the Wranglers of the Texas League and to NBC tournaments, both owned by Wichita Baseball Inc.

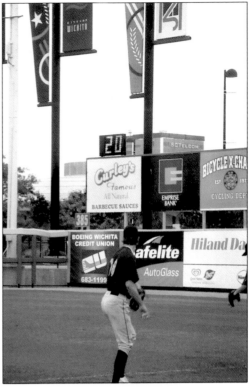

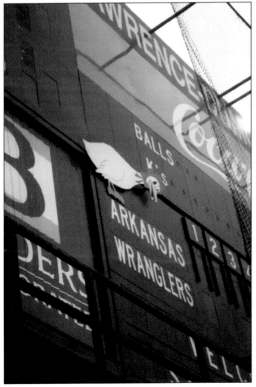

Gertie the Goose helps keep score at Lawrence-Dumont Stadium. When the visiting team fails to score, Gertie moves to the proper inning and leaves a goose egg. The original Gertie was a product of the fertile mind of Raymond (Hap) Dumont, founder of the National Baseball Congress. When L-D Stadium was revitalized with a new scoreboard, Gertie returned to her nest above the outfield wall.

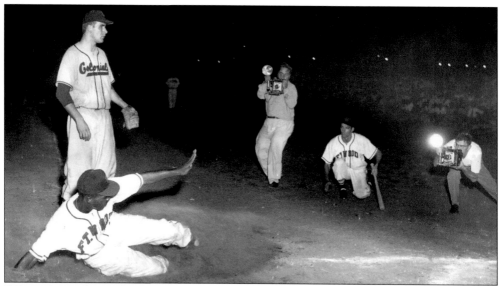

When the military battled on the diamond during the Korean Conflict, newspaper photographers with unwieldy Speed Graphic flash cameras used 4 by 5-inch sheets of film to record the action. Fort Myer, Virginia, eventual winner of the 1953 NBC tournament, fought the Fort Leonard Wood Hilltoppers throughout the tournament. In many tournaments, the flash of bulbs and loud clicks of shutters added to the excitement of the game. (Photo courtesy National Baseball Congress.)

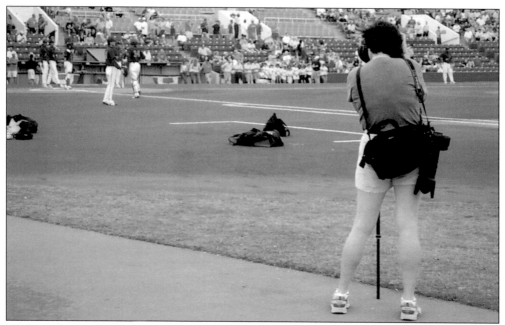

Modern photojournalists carry a minimum of equipment. Small cameras with powerful long lenses and high speed film, as well as digital cameras, make it possible to photograph Wrangler and NBC games almost regardless of lighting conditions and clearly stop action in its tracks. In this picture, a photographer for *The Wichita Eagle* has a camera mounted on a monopod to steady it while she records pre-game action.

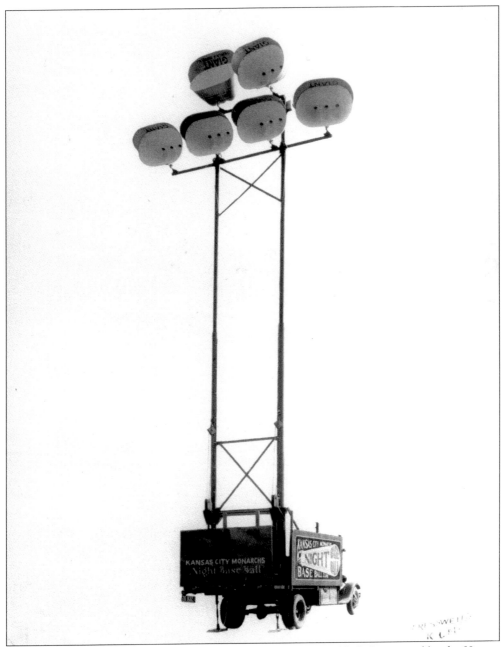

In Wichita the first night baseball game was played with portable lights owned by the Kansas City Monarchs, the famed all-black team. Battling the Depression along with everyone else, the Monarchs mounted what they billed as the "world's largest portable generator" on the back of a Ford truck along with telescoping light towers. The lights were to be used first at Arkansas City, but the game was rained out, so they made their debut in Enid, Oklahoma, against Phillips University on April 28, 1930, the same day Independence and Muskogee played the first night game in organized baseball. The Monarchs played at night in Wichita later in 1930, two years before the city's professional stadium was permanently lighted. (Photo courtesy Larry Lester, NoirTech.)

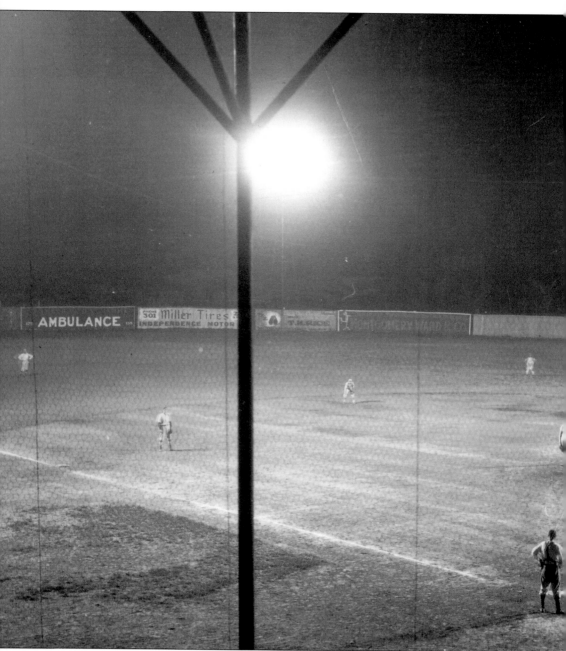

The first regularly scheduled night game in organized professional baseball was played April 28, 1930, in Independence, Kansas, between the Independence Producers and the Muskogee Chiefs before a crowd of 1,200. First pitch was thrown by Ron Vance (right), a former Wichitan making his professional debut. It was in that same park 19 years later that Mickey Mantle spent his first season playing in the KOM League. Some credit Des Moines for playing the inaugural night game because the team owner announced plans well in advance. But Independence won the "race" by four days, opening its season at home while Des Moines was on the road. Ironically, Des Moines' opponent for that first night game was Wichita, which did manage to salvage one first. The last half of the game was aired on a 60-station radio network assembled by the National

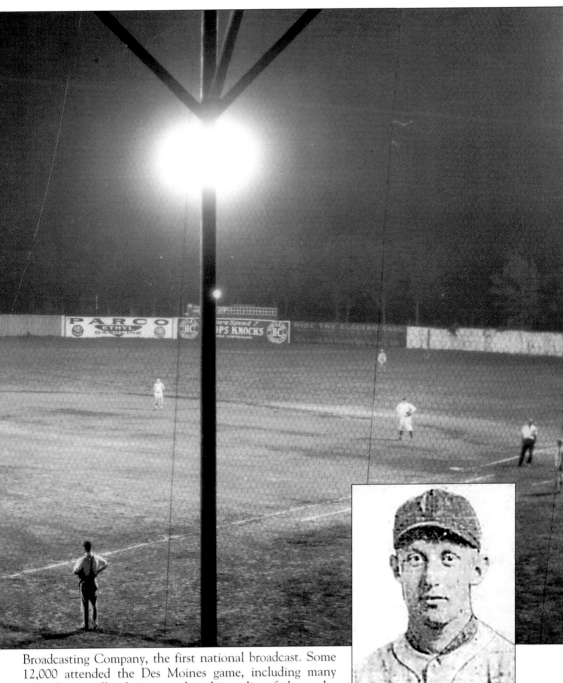

Broadcasting Company, the first national broadcast. Some 12,000 attended the Des Moines game, including many major league officials interested in the quality of play under artificial illumination. The *Encyclopedia of Minor League Baseball* credits lights with saving the minor leagues during the Depression, but *Wichita Eagle* sports editor Pete Lightner dismissed them as a passing fad in a column he wrote. Major league baseball's first night game was in 1935 at Cincinnati. (Photo above by Glenn Barrett, courtesy Westar Energy; at right, courtesy *Independence Daily Reporter* and the Independence Public Library.)

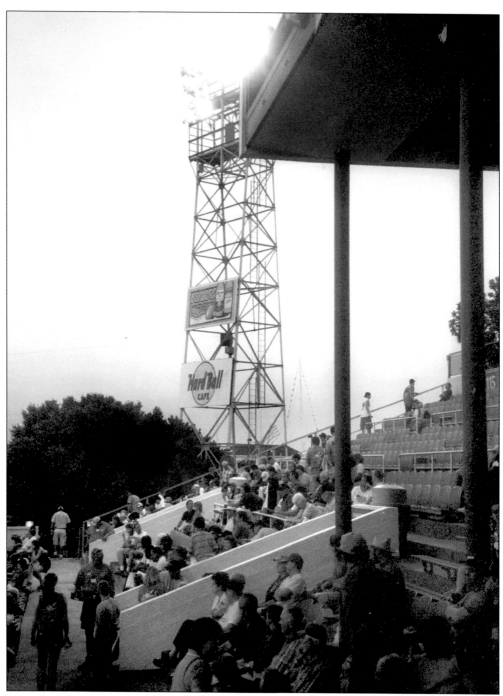

Even though its team played in the first night game in Western League history, Wichita was the last city in the loop to light its park. But it lit up dramatically in 1932. Defeating Pueblo, Colorado in the night opener, the Aviators scored 17 runs in the fifth inning, just one shy of setting a professional baseball record. Outfielder Chuck Hotstetler tripled twice in that inning for a still-standing league record. At Lawrence-Dumont Stadium, only one of the original light towers installed in 1935 still is in use. It stands just east of the main part of the stadium.

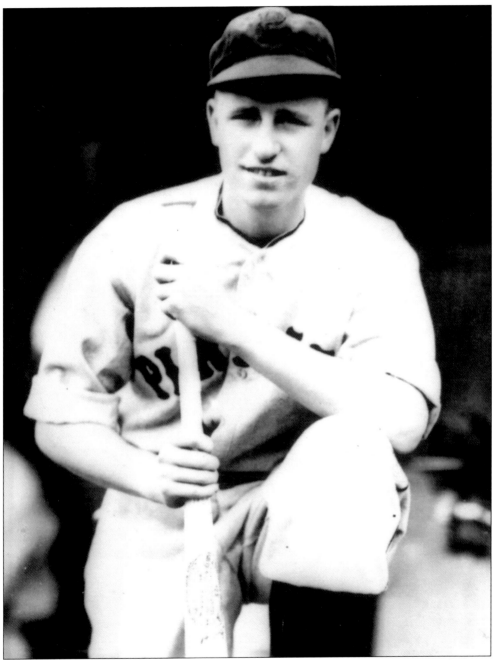

Forrest "Woody" Jensen recorded many firsts in Wichita. A native of Washington, he came to the city in 1930 to play professional baseball and became the first Western League player to bat under artificial illumination when the Aviators played the league's lighted opener in Des Moines. Returning to the city where he met and married his wife, after a nine-year big league career with Pittsburgh, he became a bowling alley operator. His Rose Bowls East and West were the first in Wichita to use automatic pin-setting equipment. Jensen also coached Wichita State University's baseball team for two seasons and was president both of the Wichita Indians and Wichita Braves.

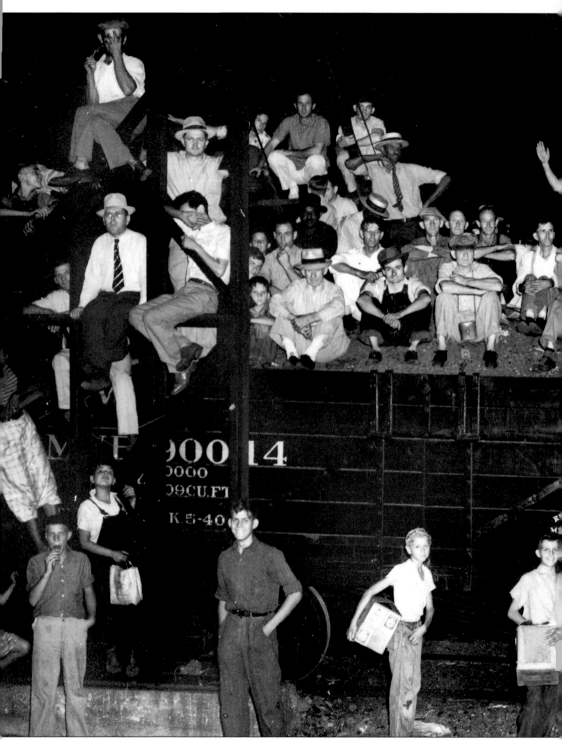

Like building tops across the left field fence at Chicago's Wrigley Field, rail cars along the right field wall at Lawrence-Dumont provided free seating for games at the stadium until a second level was added to the fence. Fans in 1940 crowded onto a coal car to watch a game. Several

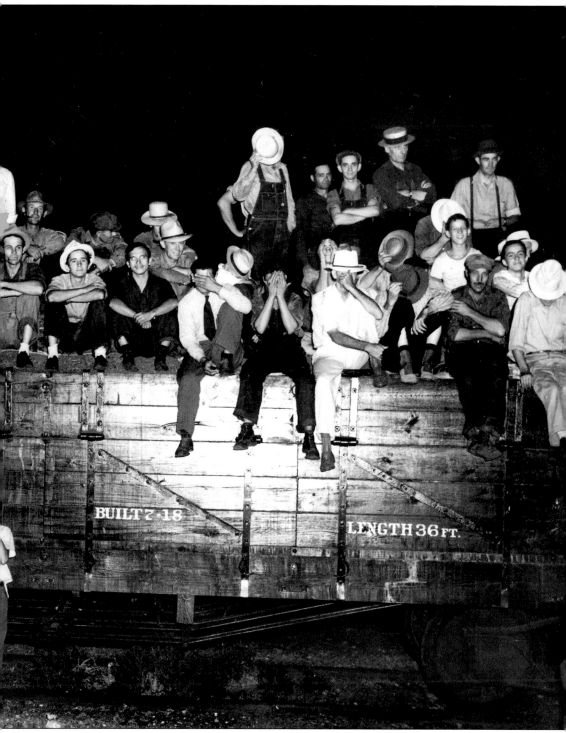

covered their faces to hide from the camera. On the ground are youngsters with boxes, vendors who worked the railroad crowd, one of them thumbing his nose at the camera. (Photograph courtesy National Baseball Congress.)

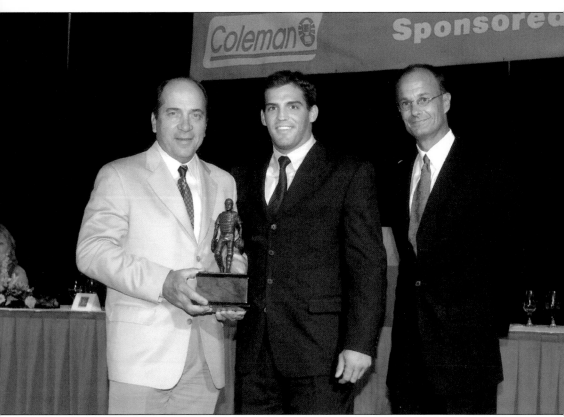

Ryan Garko of Stanford (center) receives the 2003 Johnny Bench Award from the namesake Hall-of-Fame catcher. The trophy is given annually to the nation's top collegiate catcher by the Greater Wichita Area Sports Commission at ceremonies in Wichita. On the right is Bill Phillips, president and chief executive of the Coleman Company, which supports the award. Previous winners were Jeremy Brown, Alabama; Kelly Shoppach, Baylor; and Brad Cresse, LSU. (Photo courtesy Greater Wichita Area Sports Commission and Darren Decker Photography.)

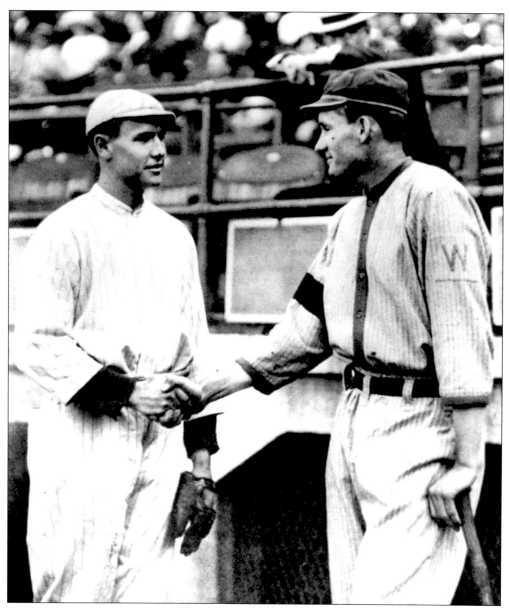

Smoke meets Train in this picture of two of Kansas' best baseball products. Smoky Joe Wood (left) was born in Kansas City but spent much of his early life in Ness City. He started his professional career pitching for Hutchinson. Walter Johnson, the "Big Train," from Humboldt and Coffeyville, became one of the game's greatest pitchers even while playing for the chronically weak Washington Nationals. He was also considered one of the sport's greatest gentlemen. Wood went to the major leagues as a pitcher, winning a league-leading 34 games in 1912. An injury caused him to play in the outfield his last three seasons. Johnson spent 21 years in the major leagues, winning 417 games, second most of all time. He also pitched a record 110 shutouts. A year after Wood won 34 games, Johnson won 36. In 1924 and 1925 the "Big Train" led the Nationals to the World Series. He also managed for two seasons and was elected to the National Baseball Hall of Fame in 1936. Wood became baseball coach at Yale. (Photo courtesy Reno County Historical Society.)

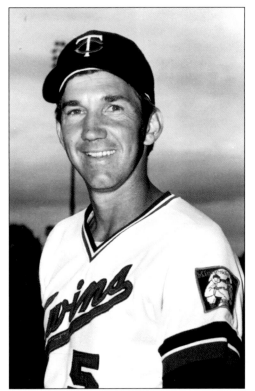 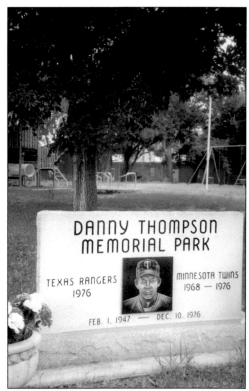

Danny Thompson (*left*) had much going for him. Born in Wichita, he spent much of his early life in tiny Capron, Oklahoma, and then became an All-American infielder at Oklahoma State University. Signed by Minnesota, he was a major leaguer by age 23. Soon diagnosed with cancer, he remained with the Twins and later played for the Texas Rangers. He died in 1976 at 29, just months after his final game. A memorial to him (*right*) was erected at Danny Thompson Park in Capron. Wichita-born Fritz Brickell died at 30 of cancer after three seasons with the Yankees and Angels. Also an infielder, he was the son of Fred Brickell, another major league player. Eric Davis, a star with the Reds, survived colon cancer. Eric had played with the Wichita Aeros. John Olerud, a star in NBC tournament play, spent a year out of baseball recovering from an aneurysm that threatened both his life and career. (Photo courtesy the Minnesota Twins)

No Kansan is better known than the commander of Allied Forces in Europe during WW II, 34th president of the United States, Dwight D. Eisenhower. Ike was a member of the Abilene High School baseball team and an ardent fan of the sport. On Honus Wagner's 80th birthday, the president, wrote a "fan letter" to the Hall of Fame shortstop. Wagner had been his boyhood baseball idol. (Photo Courtesy The Eisenhower Library)

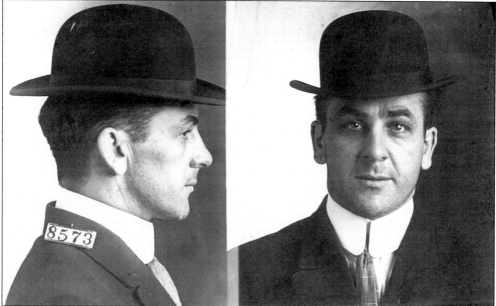

Dannie Claire was a utility player for the 1911 Wichita Western League team that moved to Pueblo, Colorado. Bringing his girlfriend back home after the season, he was arrested and convicted of taking a woman across state lines "for immoral purposes," a violation of the then new Mann Act. He was sentenced to prison at Leavenworth where he starred on the prison baseball team, staying in shape for a return to the Western League. After his release, Claire played for Des Moines. (Photo courtesy the National Archives and Records Administration.)

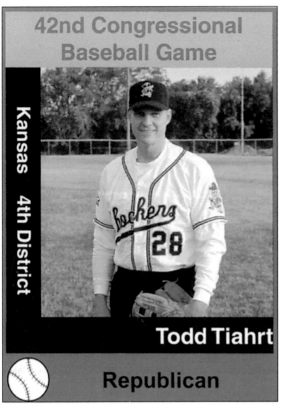

42nd Congressional Baseball Game

Kansas 4th District

Todd Tiahrt

Republican

Congressman Todd Tiahrt wears a Wichita State University baseball uniform to play first base in the annual Washington game between Democrat and Republican lawmakers. Tiahrt played for youth teams while growing up in South Dakota. But he said his best memory of baseball was WSU catcher Eric Wedge closing his glove on Greg Brummett's strikeout to end the 1989 College World Series. A veteran of nine congressional matches, Tiahrt's best game included scooping an errant throw out of the dirt and then hitting a double off Rep. Mel Watt, a Democrat from North Carolina.

What's the quickest way to become a full-fledged American? These new Chinese immigrants believed it was learning to play the national game. Here they are working out in a Wichita park in the 1930s after coming to work in a relative's restaurant. (Photo courtesy Wichita-Sedgwick County Historical Museum.)

The Shamrocks - - 1940

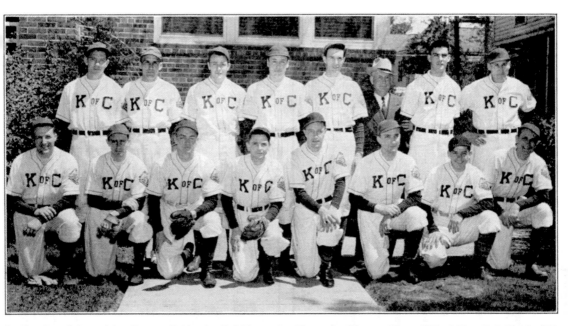

Reading from left to right: Clarence Debbrecht, Ted Moran, Joe Hesse, Jr., Vincent Oliver, Willard Van, Ted Klenda, Bill Higgins, Regis Robinson. Standing: Francis Watson, Max Bura, Noel Law, Ted Drouhard, Chet Shellenberger, Fred C. Clarke, manager; Lawrence Carney and Tom Drouhard.

"Only in America," said S.A. Long, a Shriner and master of ceremonies for the annual game between the Catholic Knights of Columbus and the Protestant Shrine. "Probably nowhere else in the world could such an event as this one be held. Here we have Masons and the Catholics contesting for a trophy presented by one of the city's leading Jewish merchants. Thank God for America!" Some 6,000 turned out for the contest. The seriousness of the match was evident in the caliber of the teams' managers. The K of C was led by Fred Clarke, soon to be elected to the National Baseball Hall of Fame. Frank Isbell, who as of 2004 was still holding a World Series hitting record, skippered the Shrine. (Photo courtesy Knights of Columbus Wichita Council 691 and Midian Shrine.)

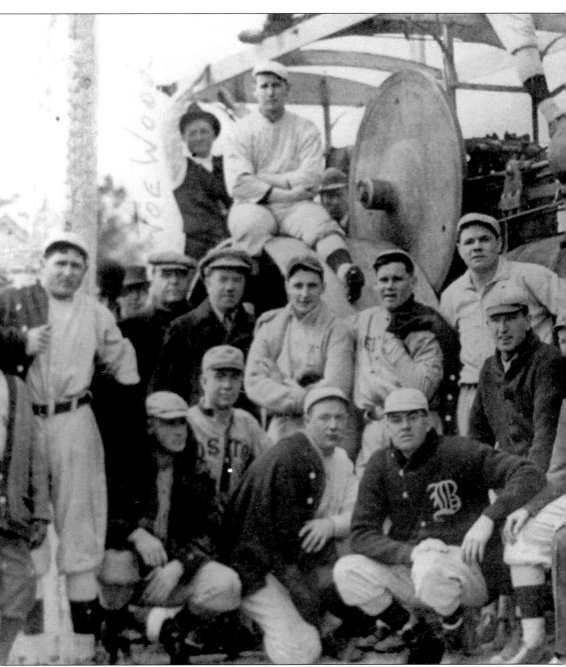

A remarkable team of barnstorming major leaguers poses with a steam engine used in threshing wheat, *circa* 1915. At center, his head almost touching the right side of the fly wheel, is Babe Ruth. To Ruth's left, and at the right of the man in the suit, is Carl Mays, the Yankee pitcher who threw the pitch that killed Cleveland's Ray Chapman in 1920, the only fatality in a major league game. Mays spent one summer pitching at Mulvane in 1908 before moving into professional baseball. Unfortunately, many of the names of those in the photo have been lost. But among those known to be included are George "Hooks" Dauss, who won 222 games in 15 years for the Tigers; Rip Hagerman, from Lyndon, Kansas, who played for the Cubs and Indians;

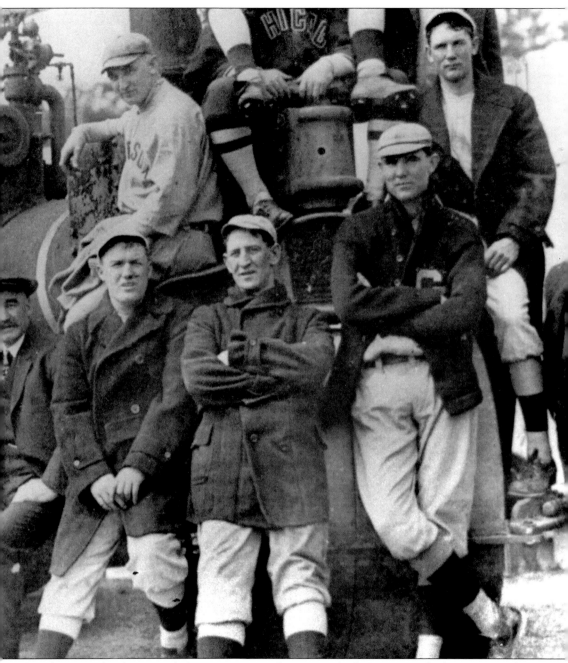

Dutch Leonard, who compiled an 11-year pitching record of 139-112 with the Tigers and Red Sox; Forrest "Hick" Cady, a catcher with the Red Sox who played in three World Series; Germany Schaeffer, an infielder-outfielder for 15 years with the Cubs, Tigers, Senators, Newark of the Federal League, Yankees, and Indians; Vean Gregg, a 92-game winner with Cleveland, the Red Sox, Athletics, and Senators over eight years; Ernie Shore, who pitched seven years for the Giants, Braves, and Reds; Bill Sweeney, an infielder for eight years with the Cubs and Braves; and Joe Burns, who spent two years as an outfielder with the Reds and Tigers. (Photo courtesy Reno County Historical Society.)

Vernon Smith pitched for the American Legion Trojan Juniors to catcher Jimmy Randall in the 1930s at a Cessna diamond on West 2nd Street. His role model was neighbor Max Clark who died while flying a P-38 during WW II. A member of the NBC Knothole Gang, Smith followed Wichita Water, Eason Oilers, and Cessna teams. While Vernon made no lasting mark on baseball, he won the 2002 Nobel Prize for Economics. Here he is welcomed back to North High School after his triumph in Stockholm. (Photo courtesy Susan Arensman, USD 259.)

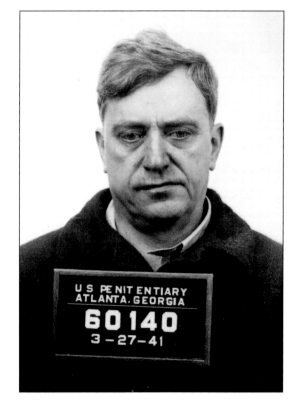

Native Wichitan Earl Browder was a sickly youngster whose outdoor play was limited. But in 1936 and 1940 he was the Communist Party's candidate for U.S. president. He faced fellow Kansan Alf Landon and Franklin Roosevelt in the first election; Roosevelt and another former Kansan, Wendell Willkie, in the second. Twice imprisoned at Leavenworth for opposing the WW I draft, he became manager of a baseball team made up of prisoners in the print shop and prison band. So-called "Inside League" teams represented prison work groups, crimes, length of sentence and race. The institution's top teams also played professional and semipro teams. Browder's final conviction was in 1940 for passport fraud and he was sent to a federal penitentiary in Atlanta where this photo was taken. (Photo courtesy the National Archives and Record Administration.)

Three

For Young Mr. Hemp, Everything Was Ducky

How did William H. Hemp's folks in St. Louis react when their 19-year-old son was called Ducky? Any answer has been lost in time. But Wichita baseball fans of 1887 did give young Hemp his nickname and made him their favorite on the city's first professional baseball team. Little wonder. He was among the first to sign, the first to bat, and the first Wichita minor leaguer to graduate to the majors.

Called the Braves, the team won the Kansas State League with a 17-10 record, and later in the summer moved into the Western League. Ducky stayed even though many of his teammates were purged when they proved ineffective against the Western's tougher opposition. Baseball's organization was far different then from what it became. Minor league teams were independent. There were no farm agreements with big league clubs, although there were wink-and-nod arrangements. Farm systems like those started in the 1930s were prohibited at the time. If teams made money, much of it came from selling players.

Ducky was hot property. By the end of his first season he was with Louisville in the American Association, then a major league, doubling and scoring in the one game he played. Returned to the minors, he reappeared in the majors with Syracuse and Pittsburgh a year later. But his career peaked then. He faded into obscurity after 30 major league games and died in St. Louis in 1923. The youngster with a waddle in his walk helped start the first of what became Wichita's 72 seasons in professional baseball, 32 of them in the Western League. But when the Leadville, Colorado franchise was moved to Wichita in 1887, it gave the city a six-week trial that almost proved fatal.

Oh, there was a great start. One of the league's premier teams, the Lincoln Tree Planters, was the first in town. Wichita upset Lincoln 8-2, inspiring *The Eagle* to exult, "Boys, you are daisies!" Unfortunately, the flowers wilted. Bill Hart, a Lincoln star, recalled that the team was "sore at the thought of being beaten by what they termed 'the dubs,' and vowed that in the next game they would annihilate them." Ghenghis Kahn was kinder to conquered cities than the Tree Planters were to Wichita. The next day, Lincoln had 50 hits—an all-time record—scoring 46 runs and setting the stage for the rest of the season. Wichita's final record was 7-32.

Bad as the team was, the city was playing in what became a major league. In 1901, Ban Johnson turned the Western into the American League. The Western did re-form as a minor league and Wichita would return to Western. Still, it took nearly a decade before the city again fielded a professional team, with minor help from one of the best-known frontier law enforcement families.

George Washington Earp helped found Ulysses in western Kansas, and was mayor before becoming deputy federal marshal in Wichita in 1894. A cousin of Wyatt Earp, who earned fame at the OK Corral in 1881, George submitted the winning entry in a contest conducted by *The Eagle* to name the new team in 1896. It was, not so amazingly, the Eagles. He won a season ticket.

On the field, the Eagles were successful, even with a slow start. In their first exhibition game, they lost 12-2 to the Kansas City Blues. But there was a crowd of 1,000 with enough boys in the trees beyond the outfield that they looked like a "line of black crows," according to the newspaper. The Eagles returned to the Kansas State League, finishing third with a 10-8 record and ended 19th century professional baseball in Wichita.

In 1905, 15 Wichita businessmen purchased the Pittsburg, Kansas franchise in the Western Association, joining Oklahoma City, Guthrie, Topeka, Sedalia, Joplin, Springfield and Leavenworth. Frank Isbell, the Chicago World Series star and Wichita plumber—his office was in the 100 block of South Main—was first choice to manage the team. But he was unable, or unwilling, to give up his job in Chicago and W.T. Kimmell, the former Arkansas City batboy, was given the reins instead. The team had one physical advantage. A new $1,500 stadium was built on South Main and dedicated April 1, 1905, at an intrasquad game. Umpiring was Norman Jitty, the player who had been knocked unconscious in the Arkansas City-Wichita game where Kimmell had served as batboy in 1885.

Kimmell's biggest qualification for managing appeared to be willingness. Through a short exhibition season, his team was unable to beat even area town clubs. When he tried to sign pitcher Larry Milton, the player refused because he felt the team lacked talent. So Kimmell put Milton in charge; he brought in players, and a dynasty was born. In its four years in the league, Wichita won twice, finished second once and third once. The 1907 team, called the Jabbers, was rated among the 100 best minor league teams of all time by Bill Weiss and Marshall Wright for the 100th anniversary of minor league ball. But all was not well between Kimmell and the new owners. Kimmell was ousted from his job but refused to go quietly. Claiming he owned part of the ball park land, he erected a barbed wire fence which stood until a court ordered him to remove it. Newspapers called the fenced area "the Cherokee Strip," apparently in honor of Kimmell's last hometown, Enid, Oklahoma

With Jack Holland managing, the 1907 team compiled a 98-35 record to win the league title. Among the stars were Clyde (Deerfoot) Milan who hit .304 and stole 38 bases before being purchased by Washington in late summer. He spent the next 33 years there as a player, coach, and manager, in 1912 taking the American League stolen base crown away from Ty Cobb with 88 thefts. One of the local players was important too: Beals Becker, just 21, from El Dorado, hit .310 and was 5-5 as a pitcher. Becker later played eight years for four major league teams. Gus Hetling, who retired to Wichita after playing, was also a leader on that team. He had played briefly with Detroit the previous year. Harry (Dick) Bayless, a Joplin, Missouri native, also went to the major leagues the following year, playing with Cincinnati.

In 1908, the company that had acquired the team, headed by President C.M. Irwin, sold it to Holland and Isbell. In 1910 Isbell bought Holland's interest, got his release from the White Sox, and became manager. By then the team was in the Western League again. The year 1911 was a watershed year. Island Park was built in the Arkansas River and Association Park on South Main was torn down, the lumber salvaged for use in a residential subdivision built on the grounds.

The early 20th century was a golden time for baseball in Wichita. Interest was high, as was attendance. *The Eagle* had a phone number to call for scores and schools dismissed early so that students could attend important games, all played in daylight hours. Yet the era also produced some of the worst teams in Wichita history. From 1913 to 1916, the team finished last in the Western League three times and seventh once. The 1914 team was 42 games behind first place Sioux City.

It wasn't just poor on-field results that plagued the team. Baseball as a sport was a risky business. In 1911 Isbell moved the team from Wichita to Pueblo when local investors failed to raise the $18,000 he wanted for the club. Pueblo had offered him annual payments plus the ball park. In 1912, a Wichita company bought the team and brought it back to Wichita. But then in 1916 financial problems forced it to move to Colorado Springs for part of the season. In 1917 Isbell returned to Wichita and brought the team back with him, managing for one year before serving as president from 1918 to 1926. In 1931 he became president of the team in Topeka.

The minor leagues were hard-hit by the deepening depression. 1933 was a disaster. The league dropped Denver and Pueblo to reduce travel expenses for the other teams. George Siedhoff's Wichita team was managed by eventual National Baseball Hall-of-Famer, pitcher Rube Marquard, but he quickly quit. On June 6 the team moved to Muskogee, Oklahoma, where things were no better. The team was evicted from its ball park and, like the Flying Dutchman, spent the rest of the year traveling, winning only 26 games while losing 95. That same dismal summer, Springfield second baseman Jake Batterson was killed by a pitch thrown by Omaha's Floyd Carlson. Back in Wichita, the ball park on Ackerman Island burned, erasing the last vestige of professional baseball.

When professional baseball returned to Wichita, the team played in the Western League again, known from 1950 to 1955 as the Indians. This time around, Wichita was more successful, and in 1956 the growing city replaced Toledo in the American Association—once a major league but then the highest level of minor league baseball.

Playing as the Braves again, the team was a winner—finishing seventh, first, and second in three years—but the Braves were a disappointment at the ticket window, drawing barely 100,000 fans per season. As a result, the team moved in 1959, leaving another professional vacuum until 1970. Then, 17 Wichitans, led by Milt Glickman, put together a new American Association entry known as the Aeros.

Unlike the Braves, the Aeros were no threat to the league title. A farm club for the woeful Cleveland Indians, the Aeros drew more fans on some days than their parent club but finished last in the league. First-year attendance was more than a quarter of a million and was 280,000 the second year, in spite of another poor on-field performance, and 276,541 the third—the best in the league.

However, the decline between years two and three evidenced a trend, and attendance in 1976 was just 124,107. Of the original investors, only Glickman remained. He hung on until 1984, absorbing losses of some $1 million. Then Bob and Mindy Rich entered Wichita baseball, buying the Aeros for enough to repay Glickman for his deficits and moving the team to Buffalo. Only once during 14 years did the Aeros finish higher than fourth. In 1972 the team won the Association's Western Division.

Although the team left town, the American Association office stayed. The AA moved to Wichita in 1972 when Aeros general manager Joe Ryan became league president. Ryan kept the office in Wichita until he was forced to resign due to poor health 15 years later.

In 1949, before Wichita had returned to professional baseball, *Eagle* columnist Pete Lightner speculated that the city would become a part of a professional league again. "There is a rumor," he said, "that a Texas League franchise will become available." He was more of a prophet than some might have imagined at the time. Lightner's speculation became fact almost 40 years later when, in 1987, Larry Schmittou bought the Beaumont franchise in the Texas League and moved it to Wichita. As of 2004, the team remains, but is under the ownership of the Riches.

Wichita was a member of another minor league too. In 1920, one of black baseball's best pitchers and managers, Andrew (Rube) Foster, organized the Negro National League, bringing order to a previously loosely organized enterprise.

Two years later, the Western League of Professional Baseball Teams was formed (it was called "the Colored Western League" in the papers), with Charles Bettis of Wichita as league secretary. The Wichita Monrovarians, named for the capital city of Liberia, played at 12th and Moseley. The Monrovarians dominated the league, winning the only pennant it ever offered. Final records have disappeared, but after 60 games Wichita had won 52 times, losing just eight.

At least two Monrovarians went on to play for the Kansas City Monarchs: catcher T. J. Young and infielder Newt Joseph.One year after his stint in Wichita, Joseph hit a critical home run to give the Monarchs the Negro League pennant. Young returned in 1933 to play for Mulvane in the Oil Belt League, perhaps the first black man to play for an otherwise all-white team in the Wichita area.

Although the league folded after one season, the Monrovarians did no,t and in 1925 defeated the Ku Klux Klan Number 6, 10-8. Newspapers called the crowd one of the largest to see a game at Monrovia Field.

Many great and memorable players came out of minor league baseball in Wichita. Based on his election to the National Baseball Hall of Fame, Arky Vaughan might be the best. A member of the 1931 Aviators, he hit .338 with 21 home runs. He then went to the Pittsburgh Pirates where he played until 1941, then moving to the Dodgers to play through 1948. In 1935 Vaughan hit .385 in the National League, one of the highest averages ever by a shortstop, and he was a perennial standout in all-star games, hitting .364 in seven. In 1941 Vaughan became the first player ever to hit two home runs in the game.

Some of the best major leaguers produced in Wichita were pitchers. Lee Smith, who set the major league career record for saves with 478, also saved 15 games for the Aeros in 1980. John Franco, the only former Aero still active in 2004, had 424 saves in his 16-year career and is still accumulating them. He pitched in Wichita in 1984, the last year of the Aeros' existence. Bruce Sutter pitched in Wichita in 1976 and then led the National League in saves for five seasons, accumulating more than 300.

Andy Benes, a onetime Pilot, won 155 times in 14 years at St. Louis, San Diego, Seattle and Arizona. Bob Turley, former Wichita Indian, spent a dozen years in the American League. As a Yankee, he led the league with a record of 21-7 in 1958. Don Larsen, another Wichita Indian, pitched the only perfect game in World Series history, striking out former Beech Flyer Dale Mitchell for the final out as the Yankees beat the Dodgers 2-0. Larsen threw just 97 pitches in that game and his overall big league record was just 81-91. Kirby Higbee, whose 22-9 record at Brooklyn in 1941 led the National League, was a 1933 Wichita Aviator. He won 118 major league games.

No former Wichita player had greater immediate impact on a major league team than Bob (Hurricane) Hazle of the 1956 Wichita Braves. Hazle was, at best, a mediocre hitter with Wichita, but the parent Milwaukee Braves desperately needed an outfielder and he got the call. And he answered. In 41 games he batted .403 with seven home runs. Over one three-week span he hit .503. The Hurricane led the Braves to the National League pennant and the team won the World Series in seven games over the Yankees. Hazle, however, cooled in the series and ended his major league career the next season.

No brothers have been better for Wichita than the Alomars who served with the Pilots in the team's first Texas League season. Roberto, a second baseman, batted .319 for the Pilots and has the possibility of a Hall of Fame bid. As of 2004, he had played 16 years in the major leagues with a career batting average of .301. His brother, Sandy Jr., a catcher, hit .308 in 1987 with the Pilots, and had also played a 16-year major league career as of 2004. The Alomars are the sons of former major leaguer, Sandy Sr.

If the Alomars were challenged as a dynamic duo, it would have been by the pitching Reuschel brothers. The better of the two was the younger, Rick, who was with the Aeros in 1972 with a 1.32 earned run average. Rick won 214 major league games in 19 seasons. Paul, who pitched in Wichita from 1972 to 1975, played five major league seasons, compiling a 16-16 record. Together, the brothers won 34 games, losing only 19 for the Aeros.

One of the best-known names of a former Wichita minor league player is Bob Uecker. A catcher for the Wichita Braves in 1957, Uecker is best known not for his six years in the major leagues but for his sportscasting and comedic appearances.

There is little question that the greatest contribution tothe world of baseball was made by a 1981 Aero outfielder...but it is as a father that he has made his mark. He is Bobby Bonds, whose son Barry, as of 2004, has set not only the major leagues' all-time single-season home run record but seems en route to the lifetime record as well. Barry, one of only four players throughout history with 600 or more home runs, played in Wichita in 1984 with the Hutchinson Broncos.

Wichita's professional baseball history is recorded on a 30-foot tower just outside Lawrence-Dumont Stadium. The tower, listing the names and years of operation for all the city's pro teams, was installed as part of a renovation of the stadium in 2001. Around the outside of the park are monuments with highlights from professional and non-professional teams in Wichita as well as many players. Under the stadium are vignettes featuring other stars.

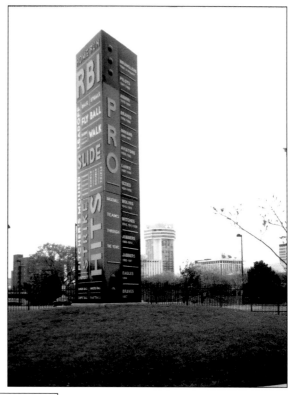

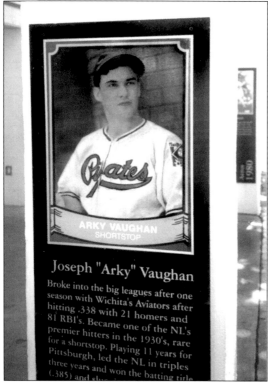

Joseph "Arky" Vaughan

Broke into the big leagues after one season with Wichita's Aviators after hitting .338 with 21 homers and 81 RBI's. Became one of the NL's premier hitters in the 1930's, rare for a shortstop. Playing 11 years for Pittsburgh, led the NL in triples three years and won the batting title (.385) and slu...

A plaque honors Arky Vaughan, the only Wichita minor league player elected to the National Baseball Hall of Fame. A shortstop, Vaughan starred for Pittsburgh and Brooklyn, but died in a boating accident not long after retirement.

field sending Hart to 3rd where he stopped as Beckley fouled out.

WICHITA.	AB.	1B.	R.	2B.	PO.	A.	E.
Hemp, rf	5	4	1	5	2	0	1
Sharry, ss	4	0	1	0	0	6	0
Haber, lf	4	0	2	0	2	4	0
Leighton, 3b	4	3	0	2	0	0	0
McClelland cf	4	2	0	3	5	0	0
Wilson, 2b	4	1	1	1	5	2	0
Hendricks, p	4	3	2	6	0	1	0
Snyder, c	4	0	1	0	3	2	0
Shultza, 1b	4	1	0	1	10	0	0
Totals	37	13	8	18	27	15	1

Lincoln.	AB.	1B.	2B.	R.	PO.	A.	E.
Hall, cf	5	2	3	0	1	1	0
Beckley, 1b	5	3	3	0	15	0	0
Long, 3b	4	0	0	0	0	1	1
Shaffer, rf	5	0	0	1	0	0	0
Dolan, 2b	4	2	2	0	2	3	0
Hoover, c	4	1	2	0	7	0	0
Herr, ss	4	1	1	1	0	4	2
Hart, cf	3	1	1	0	2	0	0
Swantzell, p	4	0	0	0	0	10	0
Totals	38	10	18	2	27	18	3

SCORE BY INNINGS.

	1	2	3	4	5	6	7	8	9		
Wichita	1	0	0	3	1	2	1	0	0	—	8
Lincoln	0	1	0	1	0	0	0	0	0	—	2

NOTES.

Don't miss the game to-day.

Boys! You are daisies.

Wichita is no snap. When Lincoln thought she could do as she pleased——it was a mistake. That's all.

Dolby ought to have more nerve, and a stronger pair of vocal cards.

This 1878 box score marked the start of Wichita's 32-season association with the Western League, the oldest minor league, which became the American League in 1901.(The Western then reformed as a new minor league.) After taking over the Leadville, Colorado franchise, Wichitans reorganized the team that had won the Kansas State League earlier in the summer and used it as the nucleus of the new team. In the first game, Wichita defeated one of the Western's strongest clubs, Lincoln, 8-2. But the Braves won only six more games, losing 32 over the rest of the season. Leading off for Wichita was William "Ducky" Hemp who became the first Wichita minor leaguer to play in the major leagues. The star for Lincoln, first baseman Jake "Old Eagle Eye"Beckley went on to become a member of the National Baseball Hall of Fame.

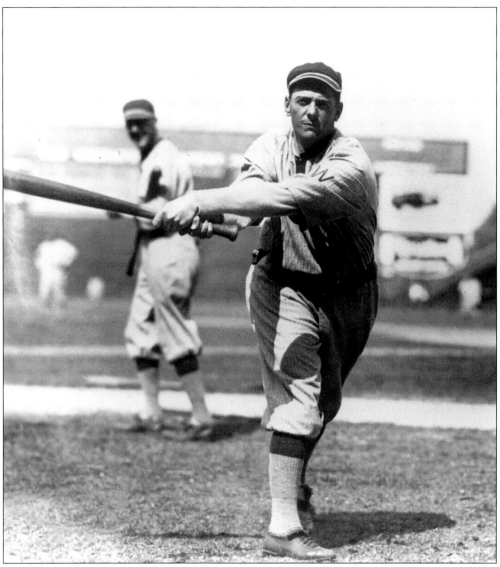

Clyde "Deerfoot" Milan was one of the first stars to play baseball for Wichita. Milan anchored the outfield for the 1907 Jabbers, picked as one of the top 100 minor league teams of all time. Although competing in the class C Western Association—the next to the lowest classification—the Jabbers were strong at every position. Milan, a native of Tennessee, was sold to the Washington Nationals in late summer and stayed for 33 years as a player, coach, and manager. Milan's strength was speed, twice leading the American League in stolen bases and dethroning Ty Cobb as league leader. As of 2004 he still ranked among the top 20 for bases stolen in a single season and for a career. His best year was 1912, when he grabbed 88. He had 495 career steals and was thrown out only 78 times. His brother, Horace, also played with Washington. (Photo courtesy the National Baseball Hall of Fame Museum.)

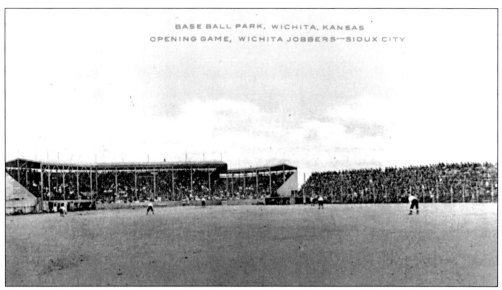

BASE BALL PARK, WICHITA, KANSAS
OPENING GAME, WICHITA JOBBERS—SIOUX CITY

Opening day pitted the Wichita Jabbers against Sioux City in a Western League game on Ackerman Island. When Wichita rejoined the Western League in 1912 (after having been exiled to Pueblo in 1911) the league was one of the strongest minors in the land. Only the American Association, International League, and Pacific Coast League were rated higher. Wichita found the fast company hard to keep. Over one five year period, it finished last four times and seventh once. However, Wichita teams were strong in later years, and landed at and near the top. (Photo Courtesy Wichita-Sedgwick County Historical Museum.)

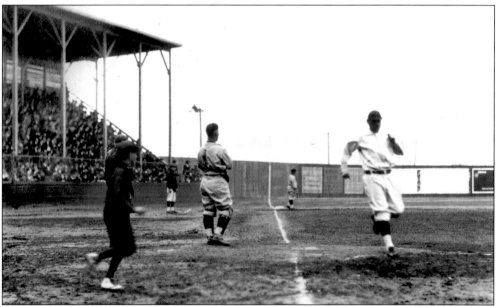

A run scores inside the Ackerman Island ball park in 1914. Built in 1911, Island Park had a wooden stadium that presented a notable safety hazard. Wood tends to burn, and the fire that consumed Island Park stadium was not unusual. Fortunately, it occurred not only after the final game of the 1933 season, but also after the city's last pre-WW II Western League team had deserted the community. (Photo courtesy Wichita Public Library.)

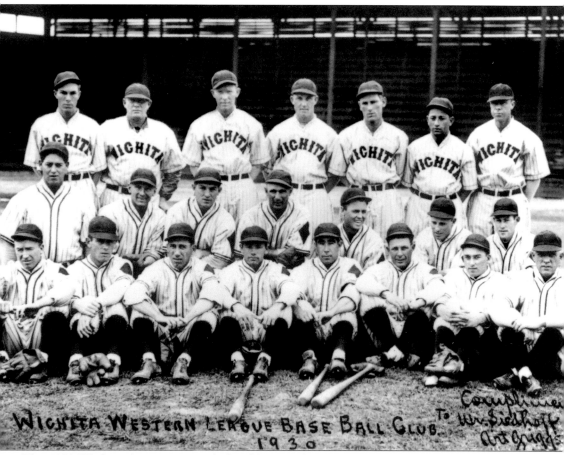

The 1930 Wichita Aviators not only handily won the Western League but also landed five players on the league's all star team—outfielders Woody Jensen and Gus Dugas, pitchers Charles "Spade" Wood and Andy Bednar, and catcher Jack Mealey. Jensen led the league in hitting with a .354 average. Dugas was second with .349. Wood had the league's second lowest earned run average. They had to contend with a young St. Joseph pitcher who went on to lasting fame, Dizzy Dean, a 17-game winner. Manager Art Griggs led the Aviators to back-to-back pennants. (Photo courtesy Wichita Public Library.)

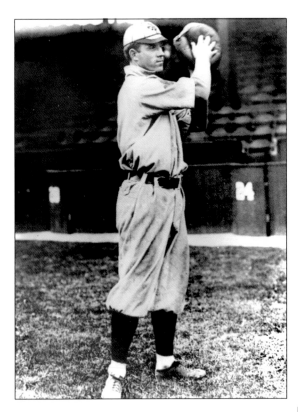

Topeka native Art Griggs spent seven seasons with St. Louis and Cleveland in the American League and Baltimore in the Federal League. Primarily a first baseman, he was versatile enough to also play the outfield, second base, and shortstop. In Wichita, Griggs replaced Doc Crandall as manager of the team then known as the Larks in the last half of the 1928 season, guiding the team to a second place finish. Griggs stayed through part of 1930, managing when it became one of the first teams ever to play a night game, and bringing the Western League pennant to Wichita. (Photo courtesy National Baseball Hall of Fame Library)

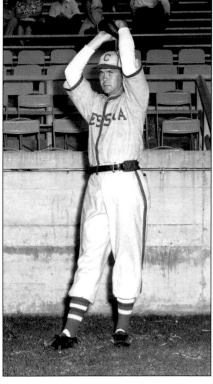

Benton native Ralph Winegarner played parts of five seasons with the Cleveland Indians and St. Louis Browns, winning eight games while losing six. Returning to Wichita, he played for the Cessna Bobcats, an area power, then in 1952 became the second person to manage the Wichita Indians in the Western League, succeeding Joe Schultz. The team finished in a sixth place tie with a 67-87 record. (Photo courtesy National Baseball Congress)

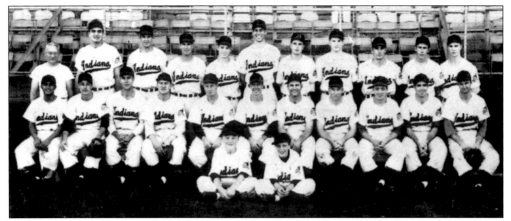

The 1950 Wichita Indians of the Western League, from left to right, are (front row) Bob Balcena, Agnelo Nardella, Steve Kovach, Mike Blyzka, Joe Schultz, (manager), Jim Morgan, John Novosel, Ed Fowler, Bob Mainzer, Charles Hopkins, and George Elder; (back row) Les Needham (trainer), Virgil Giovannoni, Don Larsen—who in 1956 pitched the only perfect game in World Series history—John Crocco, Bob Caffery, Bill Pilgram, Perry Currin, Bob Turley, Carl Powis, John O'Donnell, and Bill Bordt. The bat boys up front are Kimble and Peden. (Photo courtesy Wichita-Sedgwick County Historical Museum.)

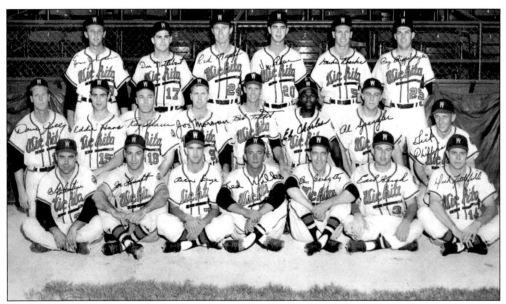

A farm club for the Milwaukee Braves, Wichita's first AAA team lasted just three years because of poor attendance, although a winner on the field. The 1958 team, left to right: (front row) Harold Valentine, Joe Lonnett, Ben Dye, Ted Wilks, Ben Geraghty (manager), Earl Hersch, and Dick Littlefield; (middle row) Dave Jolly, Eddie Haas, Ray Shearer, Dale Talbot, Ed Charles, Al Spangler, and Dick Phillips; (back row) Ernie Johnson, Don Nottebart, Red Murff—whose glove legend says was buried by teammates in the Lawrence Stadium outfield—Vic Rehm, Mike Roarke, and Ray Rippelmeyer. (Photo courtesy Max Ranney Collection.)

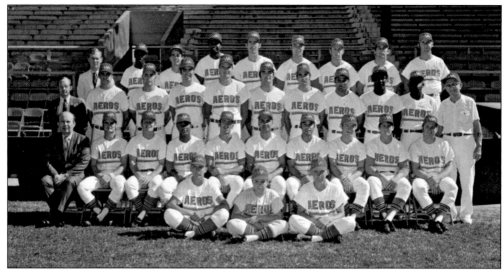

The 1970 Wichita Aeros brought American Association baseball back to Wichita after the demise of the Braves. In 1970, its first year, the team finished last but attracted more than a quarter million fans, well over twice as many as had watched the Braves in each of that team's three years. The star of the team was Chris Chambliss, in his first year of pro baseball. He led the league in hitting with an average of .342 and went on to a 17-year career with the Indians, Yankees, and Braves. He is fourth from right, second row from the top. A group of 17 local investors led by Milt Glickman purchased one of two American Association expansion franchises to bring the team to Wichita. (Photo courtesy Max Ranney Collection.)

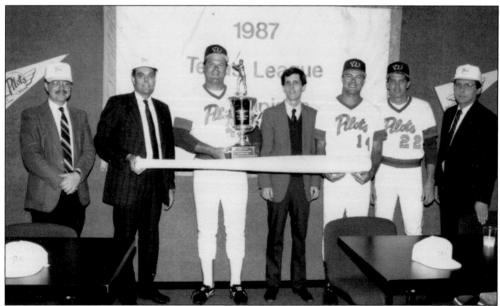

Wichita joined the Texas League in 1987 and won it all. At the end of the summer, manager Steve Smith showed off the fruits of his labors after leading the Pilots to a league title by beating El Paso and Jackson in playoffs. Here Smith is joined in front of the pennant by Larry Soice of the Wichita Area Chamber of Commerce, which was honoring the team's work. Wichita was a San Diego farm club. (Photo courtesy Wichita State University Library Special Collections.)

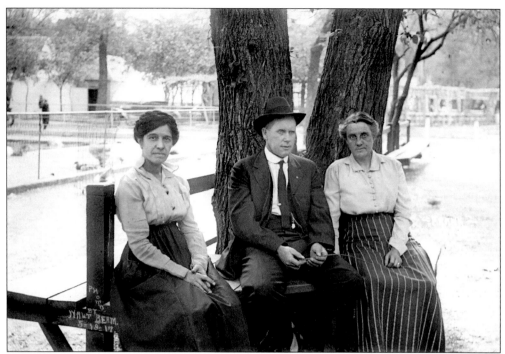

Frank Isbell, his wife, Isabell Isbell, and sister take a moment to relax under the shade of a tree in 1917, above. Right is Isbell's playing card from his nine-year major league career with the Cubs and White Sox. The second baseman set World Series records with four doubles in one game in 1906 and five errors in the series. Known as the "Bald Eagle," Isbell was an early leader in bringing professional baseball to Wichita, involved with teams in the city in 1910, 1911, and 1914 through 1926. He later became a Sedgwick County commissioner, a job he held until his death in 1941. (Photo and card courtesy Wichita State University Library Special Collections.)

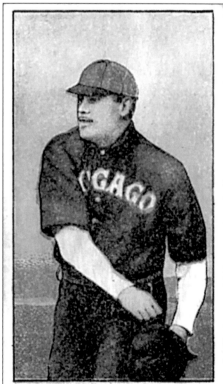

Isbell, 1b Chicago Am.

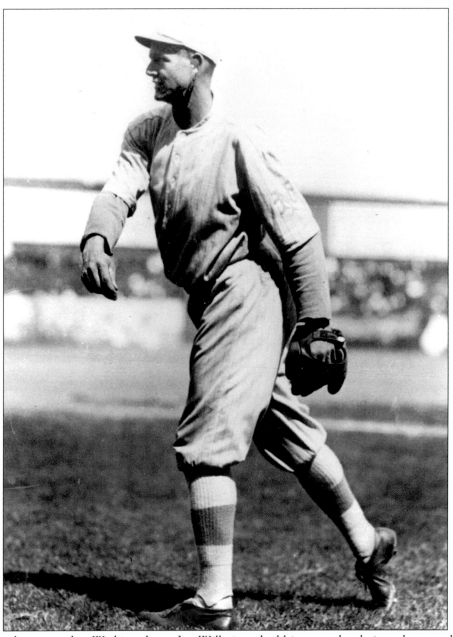

More than any other Wichita player, Joe Wilhoit etched his name deeply into the records of organized professional baseball. In 1919, after three years in the major leagues, Wilhoit came to Wichita to replace an injured outfielder and hit safely in 69 successive games, smashing the old record of 45 held by Oakland's Jack Ness. Only Joe DiMaggio has since threatened the mark, but failed both times. Wilhoit also garnered a .422 batting average to bring Wichita from near the bottom of the Western League standings to the top. When his streak finally ended, fans passed the hat, collecting $600 for him. In a league where salaries averaged $185 a month, it was a major pay day. At the end of the season Wilhoit was sold to the Red Sox, hitting .333 in limited year-end duty, but he was sent back to the minor leagues the following year and finished his career there. (Photo courtesy National Baseball Hall of Fame Library.)

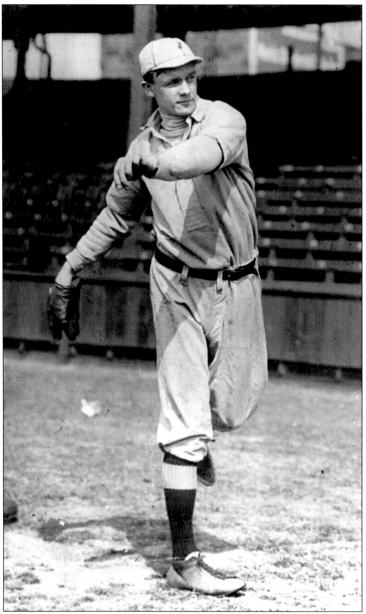

At one point, it appeared Rube Marquard might be Wichita's last professional baseball manager. He took over the team in 1933, at the lowest point of the Depression, but apparently he saw that the end was near and resigned a week into the season. The team moved to Muskogee, Oklahoma in June, where it was evicted from the ball park and played the remainder of the year on the road. However, Marquard did give Wichita the distinction of having a manager who was admitted to the National Baseball Hall of Fame. Marquard pitched 18 years in the majors, joining the New York Giants in 1908 after being purchased for the then remarkable price of $11,000. In the next three years, he led New York to three successive World Series. In 1915 he pitched a no-hitter against Brookyn, then was traded to the Dodgers and helped them win a pennant the following year. Brooklyn traded him after he was convicted of scalping World Series tickets. (Photo courtesy National Baseball Hall of Fame.)

ONLY BASEBALL IS ON TAP AT ISLAND PARK

Klan and Colored Team to Mix on the Diamond Today

Strangle holds, razors, horsewhips, and other violent implements of argument will be barred at the baseball game at Island Park this afternoon when the baseball club of Wichita Klan Number 6, goes up against the Wichita Monrovians, Wichita's crack colored team.

The colored boys are asking all their supporters to be on hand, to watch contest, which beside its peculiar attraction due to the wide difference of the two organizations, should be a well played amateur contest. On the side of the colored boys is the fact that they have had a ball team here for several years

The Wichita Monrovarians dominated the Colored Western League, winning the only championship in the league's history. While most of the other members folded with the league, the Wichita team did not, continuing to play as an independent. In 1925 the team played against a Ku Klux Klan team at Monrovarian Park, drawing what the newspapers called the stadium's biggest crowd, and resulting in a one run win for the black team. There was no violence or any other problems at the game.

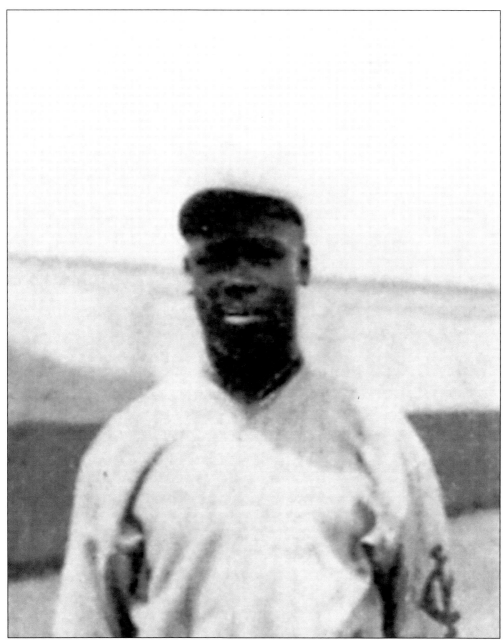

Newt Joseph was one of two Monrovarians to go on to play with the Kansas City Monarchs. A strong-armed third baseman, he hit a clutch home run to clinch the 1923 Negro National League pennant for Kansas City. He died in Kansas City in 1953. Catcher T. J. Young also played in Wichita. Once, in an exhibition game, he doubled off Dizzy Dean and tripled off his brother, Paul. In 1933 Young played for Mulvane in the Oil Belt League, making it one of the first integrated teams in the Wichita area. (Photo courtesy Larry Lester, NoirTech, Inc.)

OFFICIAL SCORE BOOK
AND MAGAZINE 10¢

It cost only a dime to buy a 1950 Wichita Indians program. It profiled manager Joe Schultz, who led the American League in hitting in 1946 with St. Louis, boasting an average of .398. After 13 seasons as a minor and major league player, Schultz was in his first year as a manager in Wichita and the team broke even—winning and losing 77 games. Nevertheless, Wichita produced one of baseball's best pitchers in Bob Turley, who won the 1958 Cy Young award. Wichita's attendance was fifth best in the league at 126,729. (Program courtesy Wichita-Sedgwick County Historical Society Museum.)

Joe Ryan, son of a former major leaguer, came to Wichita as general manager of the Aeros and became president of the American Association. A veteran baseball executive, Ryan remained in Wichita and kept the league president's office in the city for 15 years after the Aeros left town. He also helped keep the National Baseball Congress viable during the early years after the death of Hap Dumont, before its sale to Bob and Mindy Rich. (Photo courtesy National Baseball Congress.)

Milt Glickman, left, shown with his son Norman, brought baseball back to the city after the Braves left town. Glickman led 17 local investors to form the Wichita Aeros in 1970, buying an expansion franchise in the American Association. He held on through 1984, enduring losses of nearly a million dollars. He then sold the team to the Rich family who moved it to Buffalo, New York. Eventually the Riches bought both the city's Texas League team and the NBC. (Photo courtesy Norman Glickman.)

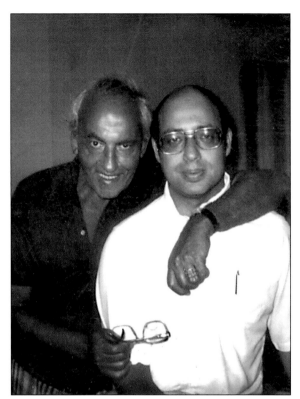

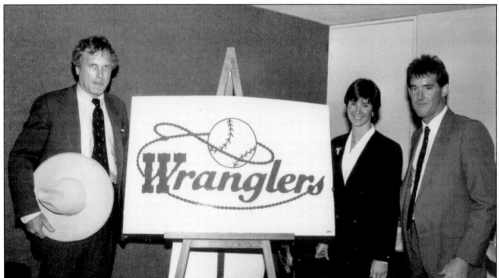

Bob (left) and Mindy Rich of Buffalo entered the Wichita baseball scene when they purchased the Wichita Aeros from Milt Glickman in 1984. They returned when they bought the Texas League Pilots from Larry Schmittou, who had moved the team to Kansas from Beaumont, Texas. With them in the photo is Steve Shaad (right), Texas League "Executive-of-the-Year" in 1990, vice president and general manager of both the Wranglers and NBC. Shaad resigned early in 2004 and was succeeded by Eric Elliott. (Photo courtesy Wichita State University Library Special Collections,)

Half of the Texas League's best—the West team—returns to the dugout before the 2003 Texas League All Star game, the third classic hosted by Wichita. The 1993 Texas League game in Wichita had ended in a tie and was settled based on a post-game home run hitting contest. Wichita's Dwayne Hosey had two homers in the game, but none in the "homer-off."

Wilbur T. Wrangler represents Wichita's baseball teams to the public in the stands. Like other hard working team mascots, Wilbur appears before the game, distributes souvenirs, leads cheers, and greets fans throughout home games—and undoubtedly he sweats a great deal inside the costume on warm summer days and evenings.

An Arkansas batter hit one that many thought was foul, but it was ruled fair by the league president. In 1957, the American Association all stars faced the then league-leading Wichita Braves, defeating the home team 5-4.

Ball park vendors dressed patriotically after the attack on the U.S. on September 11, 2000. The stands' traveling salesmen, part of baseball tradition since its earliest days, wore red, white and blue after the World Trade Center was struck by hijacked aircraft.

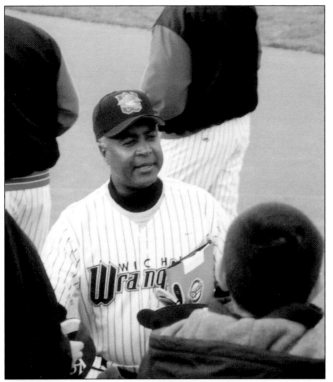

Frank White signs autographs for Wichita fans. For 18 years the second baseman for the Kansas City Royals, White became manager of the Wichita Wranglers in 2004, becoming the first African American manager in the history of the city's association with organized baseball. With 18 gold gloves, White was an American League All Star five times and Most Valuable Player in the 1980 American League Championship Series. White coached for three seasons in Boston and one in Kansas City. He also has managed in the Arizona Fall League and Gulf Coast Rookie League, and in 2004 was made co-manager of the East in the Texas League all star game.

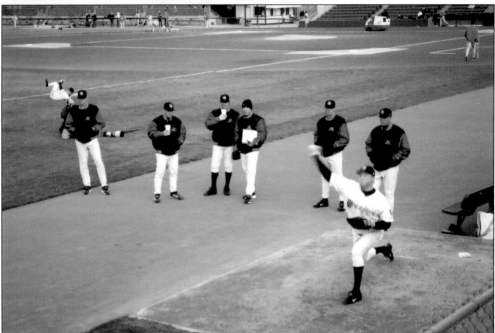

Wichita's pitching corps intently watches veteran Kevin Appier, one of many major league players who have come to Wichita for rehabilitation. Appier arrived in 2004 to pitch for the Wranglers. A resident of Paola, Kansas, he pitched 15 major league seasons, winning 169 times while losing only 136.

FOUR

Semipro Baseball is No Laughing Matter

No one ever laughed at Raymond (Hap) Dumont. And that forced a career change. The former first baseman for the Hyde Park United Brethren Sunday School team tried his luck as a stand-up comic in Chicago. He found that if the crowd doesn't laugh, the paychecks don't follow.

Chastened, Dumont returned to Kansas where he dabbled in sportswriting and promotion and sold game equipment. By 1931 he was also managing the state semipro baseball tournament. Four years later, Dumont founded the National Semipro Baseball Congress, sponsoring a national tournament in a brand-new stadium, and launching the career that earned him the moniker, "Baseball's Barnum," in Bob Broeg's biography.

"Semipro" baseball always has been something of a mystery. In 1950, when the NBC champions from Fort Wayne, Indiana, went to Japan for a series against a Nipponese all-star team, the term couldn't even be translated from English. Even in the U.S., defining "semipro" was such a problem that Dumont eventually dropped it from his organization's name.

Organized baseball is the major and minor leagues, teams that are members of the National Association of Baseball Leagues. Semipro includes all other teams, although at times semipros have been paid more than the professionals. During the Korean Conflict, the Alpine, Texas, Cowboys were giving Dodger pitcher Johnny Podres, then in the Navy, $1,000 per game to pitch in the NBC tournament—plus $100 for each strikeout. Podres earned $2,200 in one game, almost half as much as some players made in a big league season.

Even in the dark days of the Depression, outstanding semipro players commanded high pay. Jugs Thesenga was a Washington National who also won a record 14 NBC tournament games. In the 1930s he was paid $200 a game to pitch for Midwestern teams. He sometimes doubled that, having an uncle bet the $200 on the game, which he usually won, taking home $400 in a day when $100 a month was a fair wage. With Washington in 1945 Thesenga received $1,000 for a six-week stint, less per game than for his best non-pro efforts.

Semipro baseball was doing well in Wichita long before Dumont came home. The City League was formed in 1908, and at the peak during the late 1920s 49 teams were playing in eight leagues. Additionally, black teams were playing for a separate championship.

By WW II, the Victory League was founded, becoming one of the strongest semiprofessional leagues in the country. In one 23-year period, Victory League teams won a quarter of the national championships, Boeing and Wichita Rapid Transit each snaring three.

Typically, a semipro player's "wage" was his job, as companies sponsored many of the clubs and hired their players. Boeing's championship teams were made up largely of employee-players, some of whom made careers with the company. Almost all players had been baseball professionals, some in the major leagues. Fort Wayne, Indiana, a power in the 1950s, put players to work at $7,200 a year, more than many major league players earned. Wichita Rapid Transit, sponsor of the Dreamliners, signed major league veteran Bobby Boyd, who proved to be an

outstanding player for the team...and made a career of driving buses in Wichita. In 1933, when minor league baseball had all but dropped out of existence because of the Depression, former pros were a big part of the state tournament. Of 680 players that year, 216, or about one in three, had professional credentials.

In 1932 the first African Americans appeared in the Kansas state semipro tournament. The Wichita Colored Devils were the first, and won their opening game against the Reformatory Boys. By the next year, former Monarchs catcher T.J. Young was playing with Mulvane in the Oil Belt league, apparently the first club in the Wichita area to integrate.

In 1933 two black teams were in the state tournament, the powerful Ninth Cavalry of Fort Riley and the even stronger Arkansas City Beavers. The Beavers were managed by long-time Kansas City Monarch Hurley McNair and fortified with one of Kansas City's prize pitchers, Army Cooper. They made it to the semifinals before losing to another Arkansas City team, the Shell Dubbs, 11-10. By 1934, Topeka hired the Cuban Stars to represent the city, calling the team the Topeka Darkies. The 6'3", 250-pound Cooper came over from Arkansas City to manage the club. Their first game was set against the Wichita Elks, another black team imported from Oklahoma City.

Still, it was Dumont's inventive promotional mind that had the greatest impact on the non-pro sport. Dumont is credited with convincing the city to build what is now Lawrence Dumont Stadium. The L-D replaced Island Park, a wooden facility that burned after the 1933 season as a result of a discarded cigarette. Dumont was already managing the Kansas state tournament. He told Wichita that if it built the new stadium he would stage a national tournament. True to his word, in 1935 Dumont guaranteed $1,000 he didn't yet have to a Bismarck, N.D. team if it would play in Wichita. The Dakotans had a racially integrated talent-rich roster that included Satchel Paige, perhaps one of the best pitchers of all time. Paige won four games to lead his team to the national title—and Dumont's $1,000, which came from the tournament's proceeds.

Hap churned out innovations faster than most could be inaugurated. Still in use: a clock that limits the time between pitches and innings to help speed tournament play. On the scoreboard at Lawrence Dumont a goose lays an egg for the opposing team's score if it fails to tally a run in an inning. Before the stadium was remodeled, an underground microphone behind home plate rose at the umpire's command so he could announce lineup changes—it also enabled the crowd to hear umpire-player arguments (that ended when someone decided that the conversations were not suitable even for most baseball fans). And with one push of his foot, the official could clean home plate with a burst of compressed air rather than relying on the traditional broom. It was Dumont who first used the batting helmet to protect players' heads. He converted football headgear in the late 1930s, but could not then make the device popular.

The biggest rule tinkering credited to Dumont, however, was permitting the batter to run either to third or first base after hitting the ball. In 1944, he staged an exhibition between Beech and Boeing teams, Beech winning, 12-6. Two of the runs scored on a double steal of home—one runner coming toward the incredulous catcher from each direction. Because two runners could occupy the same base if they were traveling in different directions, in the seventh inning Beech's Les Lowry become the only player in history to bat in five runs with a single hit, a triple.

Major league scouts who watched the exhibition were divided about it. Tom Greenwade of the Dodgers said it "has some game appeal." But the Cardinals' Runt Marr was less enthused: "We're having enough trouble teaching our kids about baseball without this." Even Dumont may have agreed. He never tried it again.

War forced Dumont into another experiment. With WW II looming, it was unclear if baseball would be permitted to use electricity for night games. Hap had an answer. He painted balls, gloves, caps, bases, bats, home plate, and foul lines with glow-in-the-dark paint, then had players try play. Lack of depth perception doomed the experiment. Fortunately for players' health, the lights stayed on.

Besides innovation, Dumont took advantage of every chance to save money. When Mickey Flynn, a former minor league catcher who managed a semipro team in Wichita, signed with the House of David, Dumont made a side deal with him. Flynn, who was to catch 50-year-

old Grover Cleveland Alexander for the religious team, would get extra expense money as he toured the country to call on Dumont's state commissioners, saving the cost of a trip by Dumont himself. Flynn was delighted. He was already being paid $10 a game plus expenses by the Davids. Dumont's offer was a bonus.

WW II had a profound effect on the Wichita tournament. By late 1942 minor leagues were folding for the duration and the military was rapidly draining talent from all levels of the game. Boeing, in 1942, became the last civilian team to win an NBC championship until after the war. Pete Rieser, Ralph Houk, Rex Barney, Kirby Higbee, Van Lingle Mungo, Peanuts Lowery, and Cecil Travis were among the established major league players brought to Wichita in military as well as baseball uniforms. Other stars appeared in different roles. The press box was abuzz when Lt. Hank Greenberg stopped to watch a session. And much was made over native Kansan Joe Tinker, a member of the National Baseball Hall of Fame, who coached an Army Air Corps team.

Travis led the stars into the tournament and typified the war's impact on many men. He joined the Washington Nationals in 1933 at age 20 and the following year became the regular shortstop, averaging above .300 for his first eight seasons. By 1941 he was the American League's all star shortstop. The next year he was in Wichita, a corporal playing for and managing a Camp Wheeler, Georgia, team known as the Spokes.

The Wichita Eagle sports editor Pete Lightner described his coming: "For the first time, a real genuine big league batsman played in the semi-pro tournament, not an all time, fading star but a young man in his prime, Cecil Travis, just 28...a man who outhit such great ones as Gordon, Dickey, DiMaggio and York last year..." Then he described him as "a very fine ball player, a clean ball player and a gentleman who played with no thought of monetary reward."

Travis and the Spokes appeared in three national tournaments, winning one as Cecil rose in rank, becoming a staff sergeant by 1944. In Europe that fall, he took part in the Battle of the Bulge where his feet were so badly frozen that, combined with his age, his baseball career was doomed. He played only one full season after the war, hitting just .241. His military service may well have cost him a chance at the Hall of Fame.

Some players paid an even higher price. Frank (Creepy) Crespi, a St. Louis Cardinal from 1938 to 1942, suffered a career-ending leg injury while playing for Fort Riley in the tournament in 1943. His only consolation was $500 from the Wichita Old-Timers Baseball Association. Even more grave, *The Eagle* reported in 1944 that "Johnny Hill, most popular first baseman in tournament history, was killed in action in the European invasion. He was with the Mt. Pleasant Cubs here two years..."

On the other hand, some players made the enemy pay. Harry Walker, who also played with Fort Riley, in 1945 was credited with killing 13 Germans and capturing 10 others in a two-day battle for a bridge in Austria. Walker played 11 years in the major leagues and in three World Series. He carried a "souvenir" of his NBC experience with him. Because he constantly adjusted his cap while batting, Walker was known as "The Hat," a name given him while in Wichita.

Not all professional players went into the military. Many industrial teams had major and minor league players whose physical condition, age, or profession kept them out of the draft. Boeing's 1942 national champions included Fred Brickell and Woody Jensen, both ex-Pirates, and former Cub Tom Angley. But defense work was serious. Boeing Vice President and General Manager Earl Schaeffer ordered players to work during tournaments regardless of game demands. The war came first, Schaeffer said.

Some of the biggest crowds in NBC history were drawn by a combination of talent on the field and the money earned by workers in the city's around-the-clock defense factories. The biggest Sunday crowd in tournament history, almost 12,000, was in 1944 when Higbee, of the Dodgers—once of the ill-fated 1933 Wichita Aviators—opposed the Yankees' Vic Raschi in one game, and Mungo pitched against Herman Besse of the A's in another.

Some even give the NBC at least a minor role in one of the United States military's greatest triumphs. As the Korean War started, plans were made to send the winner of the Wichita tournament to Japan to play that country's top non-professional team. Fort Wayne, Indiana, a

perennial power of the era, won. In spite of heavy wartime demands for air transport, the team was given priority to fly to the island for the series, which it won. C.C. (Cookie) Cookson, long-time Dumont aide, was given back his WW II rank of captain to accompany the team.

The question posed later was whether the series was part of an elaborate cover intended to project an air of normalcy for U.S. forces to mask Gen. Douglas MacArthur's planned invasion of Inchon. The attack probably saved the U.N. on the Korean peninsula but the NBC's role, if any, has never been proved.

As America changed, the NBC began to change by the early 1970s too. Before that time, town and industrial teams dominated the tournament in non-war years, but their influence was declining. Leading players had usually been former professionals, although there always were scouts at the games, looking for and finding new talent. But by the '70s, tournament players were largely prospects, younger players who usually came off college teams. Teams from Alaska were essentially college all stars, as were similar clubs from Boulder, Colorado and Liberal.

One result of the turn to youth has been a greater number of major league players coming out of the tournament. More than 300 who played in Wichita have gone on to the big leagues, including some of the game's biggest names. But in 2003 what may signal still another turn occurred. The Taiwanese National Team from Taipei became the first non-U.S. team to win. It defeated a college-heavy team from Santa Clara, California, in the championship game.

The NBC has furthered an essential social cause. Since the beginning, it has included black players and those of other races. Paige's 1935 team was fully integrated. Several all-black clubs were entered and many finished well. During WW II, before the military itself was integrated, there were multiracial military baseball teams in the tournament. In 1943 an Army Air Corps team from Salt Lake City brought three black players to Wichita. In 1945 the Sioux Falls Marauders won their third round game over an Arizona Air Corps team behind Riley Stewart, a black player, who pitched eight shutout innings to win 2-0.

A woman appeared in an official role during WW II. Dumont hired 20-year-old Lorraine Heinsch from Kenosha, Wisconsin to work the bases one day. (Dumont called her a "Wump" for "woman umpire.") Although Lorraine did a good job, Dumont said, he sent her home, fearful of the language she was hearing and her effect on the players. The players "couldn't carry on their regular chatter," he noted. Hap did not have to protect the sensitivities of another of his umps: Luther Taylor, a 116 game winning pitcher with the turn of the century New York Giants, umpired in 1944. Nicknamed "Dummy," in that *not* politically correct era, Taylor could neither hear nor speak.

Dumont died in 1971. The NBC then went through a series of owners and partnerships—Dee Hubbard, Fran Jabara, Rusty Eck, Earl Callison, Byron Boothe, Jerry Blue, Ron Fine, and Joe Ryan. Stability finally came when the NBC was purchased by the Rich family of Buffalo, New York, which also owns the Wichita Wranglers. This union ended scheduling problems between the city's professional team and the non-professional tournament.

In 2005, the NBC observes its 70th anniversary.

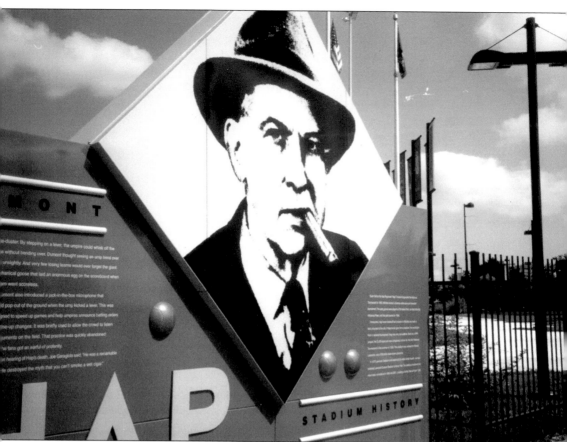

It's likely that no one has had a greater effect on baseball in Wichita than Raymond H. Dumont—called "Hap" for Happy—founder and longtime president of the National Baseball Congress, shown here as he appears on his NBC Walk of Fame monument. His career probably started by accident. After Dumont graduated as valedictorian from East High School, a friend on the show-business paper *Variety* helped book him into neighborhood theaters in Chicago as a comedian. Unfortunately, Chicago audiences were tough. Rather than return to Wichita in defeat, Dumont went to Topeka to help stage prize fights, and then expanded to Hutchinson. Lured back to Wichita by a sportswriting job at *The Eagle* and a job at Goldsmith's Sporting Goods, he promoted his first baseball game by pitting circus clowns against a local team. The game drew 3,500 fans but left Dumont with only $23 in profit after expenses. By 1935, however, he formed the National Semipro Baseball Congress and staged his first national tournament. An untiring promoter, his biography by Bob Boerg is entitled *Baseball's Barnum*. NBC alum Joe Garagialoa is quoted on the monument saying Dumont proved one thing: "It is possible to smoke a wet cigar." He was rarely seen without a well-chewed stoagie in his mouth.

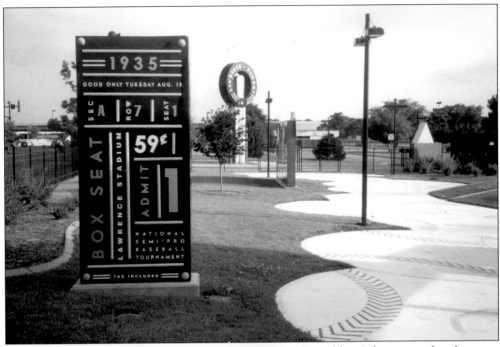

One of five 8-foot vertical sculptures honoring outstanding NBC participants is devoted to Arnold Thesenga. Called "Jugs," derived from "jughandles," an early term for curve balls, Thesenga won 14 games in nine national tournaments, more than any other pitcher. In 1944 Jugs was signed out of the tournament by the Washington Nationals and within a week pitched five scoreless innings against the Yankees in New York. Unfortunately, his later outings were less successful and he was released after the season.

Arnold Thesenga has more wins, 14, than any other pitcher in NBC history. Thesenga played in nine national tournaments in Wichita. The "Jug" was short for "jughandle," an archaic expression used to describe the degree of curve on a pitcher's breaking ball.

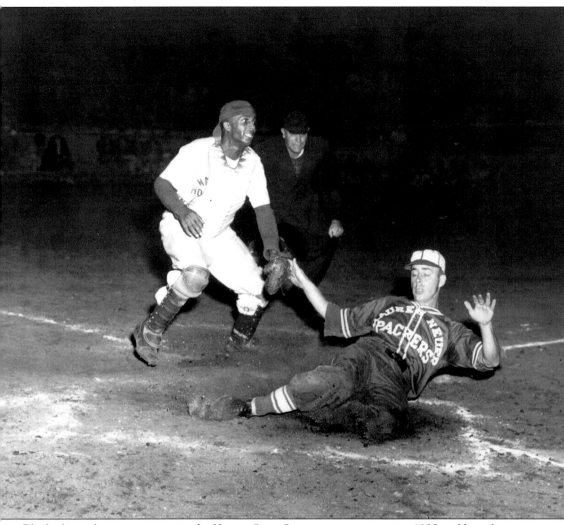

Black players began to appear in the Kansas State Semi-pro tournament in 1933 and have been a fixture since. In this photo, the catcher waits in vain for a throw to stop a sliding Arkansas City base runner. In 1933, the all-black Arkansas City Beavers were one of the state's best teams and engaged in a hotly contested rivalry for honors with the Arkansas City Shell Dubbs, a white team which defeated the Beavers by one run in the state tournament. By 1935, with the start of the national tourney, black teams were common entrants. Many cities, including Topeka and Fort Scott, hired professional black touring teams to represent them in the nationals. (Photo courtesy National Baseball Congress.)

Hubert King was one of three King brothers in the outfield for the Colored Devils who defeated the Reformatory Boys in their first game of the 1933 state tournament. Hubert was one of the first black athletes at the University of Wichita, named an all-state end in football. In this photo, taken from a Wichita University yearbook for 1930, King is shown wearing a letter sweater. (Photo courtesy Wichita State University Libraries Special Collections.)

Hurley McNair was a veteran of Negro League play, including stints with the Chicago Giants, Chicago American Giants, All Nations, Detroit Stars, Kansas City Monarchs, Gilkerson's Union Giants, and Cincinnati Tigers. But in 1933 McNair interrupted his career to manage the Arkansas City Beavers and helped turn them into one of the state's best semipro teams. Part of his success was because of the presence of another former Monarch in Ark City, pitcher Army Cooper. In 1934, Hurley went back to the Monarchs. An innovative baseball teacher, he taught Willie Wells to hit a curve ball by tying his leg to home plate to keep him from moving away. (Photo courtesy Larry Lester, NoirTech.)

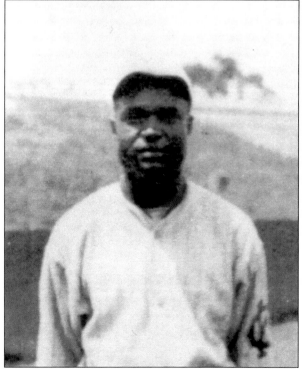

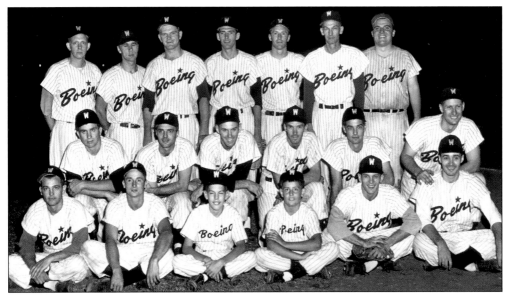

One of the strongest Boeing teams won not only the 1954 and 1955 national crowns but also the first Global World Tournament in Milwaukee. Pictured here, from left to right, are: (front row) Dud Carson, Minor Scott, batboys Wayne Eppler and Gary Logan, Vernon Frantz, and Delos Smith; (middle row) Jim Upchurch, Gene Rogers, Daryl Spencer, Les Layton, Jim Mitchell, and Ernie Logan; (back row) Jim Morris, Steve Kovach, John Konek, Mike Webach, Andy Teter, Cy Eppler (manager), and Loren Packard. Virtually all had played professionally. (Photo courtesy National Baseball Congress.)

Three of the first seven NBC tournament champions came from Enid, Oklahoma. First were these Eason Oilers who were champions in 1937 and runners-up the following year. Returning as the Champlin Oilers, Enid won again in 1940 and 1941. Then the city's Army Air Corps base became the number two team in 1943 and '44, and won it all again in 1945, anchored by major-leaguers-to-be Cot Deal and Lou Kretlow. (Photo courtesy Wichita Public Library.)

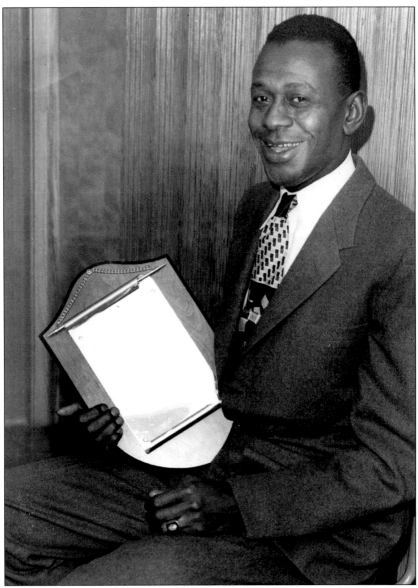

Leroy "Satchel" Paige is believed by many to be the most talented pitcher ever and his National Baseball Congress record helps prove that. Paige came to the 1935 tournament with an integrated Bismarck, North Dakota team, the Corwin-Churchills. Considered a team that could have competed evenly against most major league clubs, the Churchills had both black and white players 12 years before Jackie Robinson's signing ended the black lockout from organized baseball. Paige won four games, striking out 60 batters—still a single tournament record—to lead his team to the championship. Paige became the oldest rookie in major league history when he was sold by the Kansas City Monarchs to the Cleveland Indians on his 42nd birthday. He had a 6-1 record as the Tribe won the 1948 American League pennant and World Series. Paige last pitched in the majors at age 59—probably. Paige's birth date is such a mystery than even the National Baseball Hall of Fame Yearbook lists it as different years on different pages. A year later he pitched in the NBC tournament again with the Weller Indians. Here he holds a plaque earned for his contributions to the NBC. (Photo courtesy National Baseball Congress.)

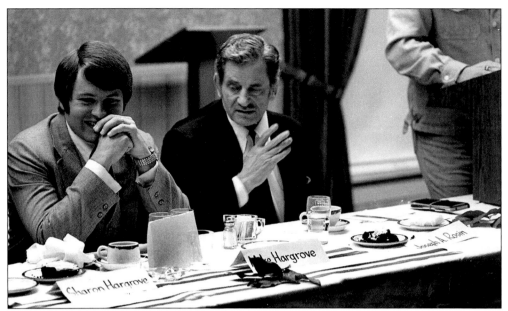

Mike Hargrove, left, relaxes at a dinner in his honor. Hargrove, a native Texan who was schooled at Northwest Oklahoma State University, played in the NBC with Liberal in 1972. A first baseman, he was in the major leagues for 12 years with Texas and Cleveland where he was sometimes called "The Human Rain Delay" for his numerous times at bat. He also became a big league manager. (Photo courtesy National Baseball Congress.)

Albert Pujols was a member of the 1999 Hays Larks. A native of the Dominican Republic, he moved to Kansas City at age 16 with his father. Pujols played professionally just one year when at age 21 he broke into the St. Louis Cardinals' starting lineup to set National League rookie records for runs batted in and extra base hits, becoming the hands down Rookie of the Year. (Photo courtesy St. Louis Cardinals.)

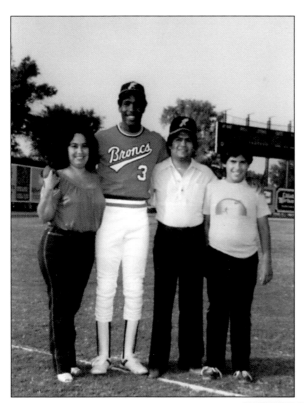

Barry Bonds may well prove to be baseball's most productive home run hitter with the single season record of 73 already his, and the lifetime record within reach. Bonds is shown here as a Hutchinson Bronco with the family that hosted him for the summer of 1984. He was part of what might have been the greatest ever NBC outfield, sharing it with Raphael Palmeiro and Pete Incaviglia. Collectively they were called the "million dollar outfield" for their combined signing bonuses, a huge amount for the time. Yet even with those three, and future major league catcher Rick Wrona, Hutchinson did not make it to the NBC finals. (Photo courtesy Reno County Historical Society.)

Mark McGwire played in the NBC tournament with Anchorage, Alaska, in 1982, broke the major league rookie record for home runs, and finally became the first major league player in history to hit 70 home runs in a season, breaking Roger Maris' record of 61 set in 1961. McGwire was in college at USC when he went to Alaska for the summer, and finally to Wichita. In 15 years in the major leagues with Oakland and St. Louis, McGwire hit 583 home runs. (Photo courtesy St. Louis Cardinals.)

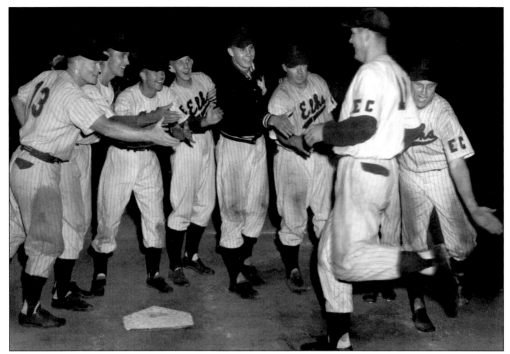

Joe Bauman is greeted at home plate in the 1950 NBC tournament after a home run. Fans would get used to seeing his trot. In 1954 he became the first professional player to hit 70 homers in a season by cracking 72 for Roswell, New Mexico in the class C Longhorn League. He accomplished that in only 140 games, so he was averaging slightly more than one four-bagger every other game. He broke the organized baseball record of 69 shared by Joe Unser, of Minneapolis, and Bob Crues, of Amarillo, before finally yielding it to Barry Bonds. (Photo courtesy National Baseball Congress.)

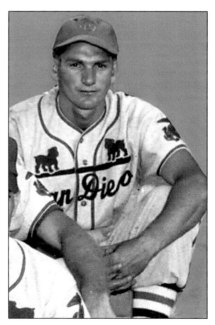

Floyd Economindes had the best view of Joe Bauman's record breaking home runs. He was catching for rival Artesia when Bauman set the record by hitting three home runs in the season's final two games. A veteran minor league catcher who was with the NBC with a Marine Corps team, Economindes said Bauman hit a fast ball thrown by a 19-year-old Cuban-born rookie for his record breaking 70th home run. Bauman hit two others that day to finish with 72. Economindes later became mayor of Artesia. (Photo courtesy National Baseball Congress.)

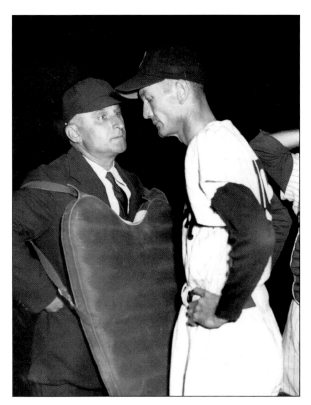

Rhubarbs are a baseball tradition, ranging from the mannerly to the maniacal. Here Boeing manager Cy Eppler gets face time with an umpire, trying to cool off hotter-headed players. (Photo courtesy National Baseball Congress.)

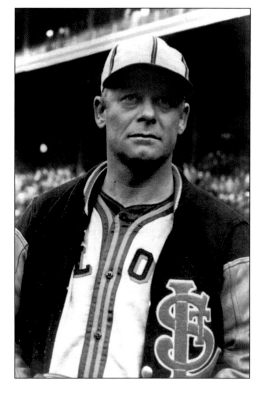

In a classic confrontation, pitcher Sig Jakuci dangled umpire Leo Kalis off the Douglas Avenue bridge over the Arkansas River while he explained the art of umpiring. Jakuci, a 6-foot-3, 200-pound right-hander who won 25 games in three seasons with the St. Louis Browns, was with the 1940 Waco Dons. He later explained that he disputed Kalis' decision because it had cost the Dons $1,000, a large amount at the time. (Photo courtesy National Baseball Hall of Fame Library.)

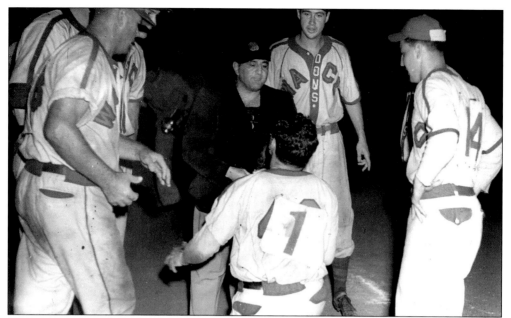

If arguing won't work, perhaps begging will. And, then, maybe not. Waco Dons manager-catcher Jerry Feille goes to his knees in a vain effort to persuade the official to see things Waco's way in the 1940 national tournament. Jakuci's showdown with umpire Leo Kalis grew out of Feille's failed attempt to change the umpire's mind. (Photo courtesy National Baseball Congress.)

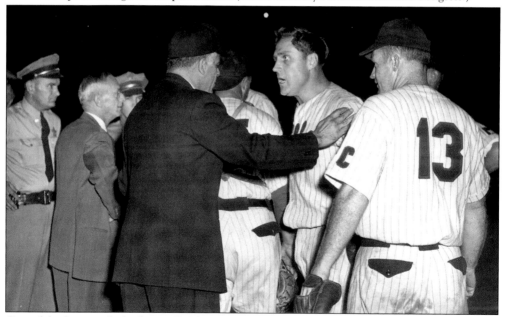

One of the longest rhubarbs in NBC history occurred in 1950 when the Elk City Elks protested a home run that had been called fair. Umpire Elmer Tielker's nose was bloodied by a blow, allegedly struck by an angry Bill Stumborg, seen here. He and manager Rip Collins—who supposedly downgraded umpire Reb Russell's family tree—were both ejected. Fifteen police officers were dispatched to maintain order during the 45-minute confrontation. (Photo courtesy National Baseball Congress.)

Alfred Manuel (Billy) Martin had to get used to being deliberately walked in the 1954 NBC tournament. Perhaps the most popular player in NBC tournament history, Martin was in the Army, stationed at Fort Carson, Colorado, when he came to Wichita with a team from Colby where he was named most valuable player in the state tournament then starred in the national. Bringing in professional player-servicemen was common, but the colorful Martin was an instant hit. He played 11 major league seasons before turning to managing. A fiery competitor, Martin once got into a brawl with one of his own coaches. (Photo courtesy National Baseball Congress.)

Since the NBC tournament's inception, major league scouts have been a fixture, not only finding new talent for their clubs but lending credibility to the tourney as a breeding ground for future major league players. Today's scouts come armed with radar guns to measure the speed of pitches. Living like gypsies much of the year, many modern scouts work for combines—groups of clubs jointly supporting scouts whose reports are shared. The major league draft also has dramatically altered the way in which new talent is signed.

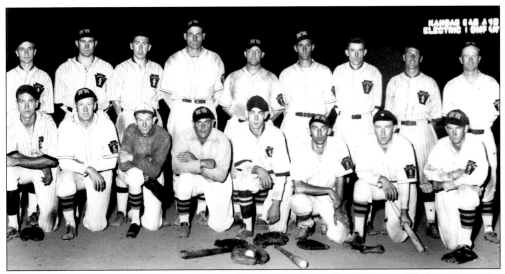

The dominant semipro team in Wichita and Kansas in the early 1930s was Wichita Water. In fact, "Beat Wichita Water" became the rallying cry for town teams trying to make their way through the state championship. This 1933 team won both the city and state titles. Pictured, from left to right, are: (front row) Dietzel, Becker, Thomas, Andrews, Carney, Schreffler, Hempfhill, and McFadden; (back row) Dominick (manager), Daugharty, Moore, Hoge, Nichols, Grove, Spencer, Lowe, and Bondurant. In 1935 the team played in the first game of the new national tourney, beating Gadsden, Ala., 4-3. (Photo courtesy Wichita Public Library)

Sgt. Clarence "Hooks" Iott (left) and Pfc. Frank Lamana anchored the Kearns, Utah, Army Air Field in the 1944 NBC tournament. Their AAF Overseas Replacement Depot team had a 25-1 regular season record behind the two stars. Iott set the NBC record for most career bases on balls with 51 but still made it to the major leagues. Unfortunately, his wildness followed him to the big leagues where in 82 innings pitched he walked 67 while fanning only 53. Lamana had pitched three seasons for Boston before WW II. (Photo courtesy U.S. Army Air Forces)

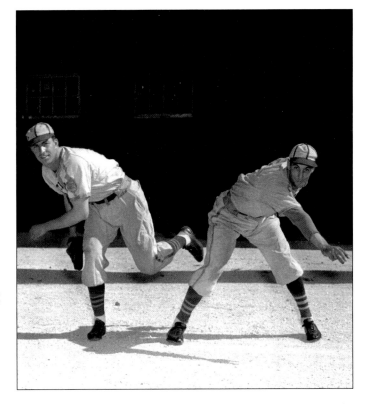

Wichita's own Boeing Bombers took home the NBC Tournament Championship in 1955. Posing here with their trophy, from left to right, are: (front row) Dud Carson, Minor Scott, Wayne Eppler (batboy), Gary Logan (batboy), Les Layton, Vernon Frantz, Jim Mitchell, and Ernie Logan; (back row) Gene Rogers, Jim Upchurch, Daryl Spencer, John Konek, Jim Morris, Cy Eppler (manager), Mike Werbach, Andy Teter, Steve Kovack, Loren Packard, and Delos Smith.

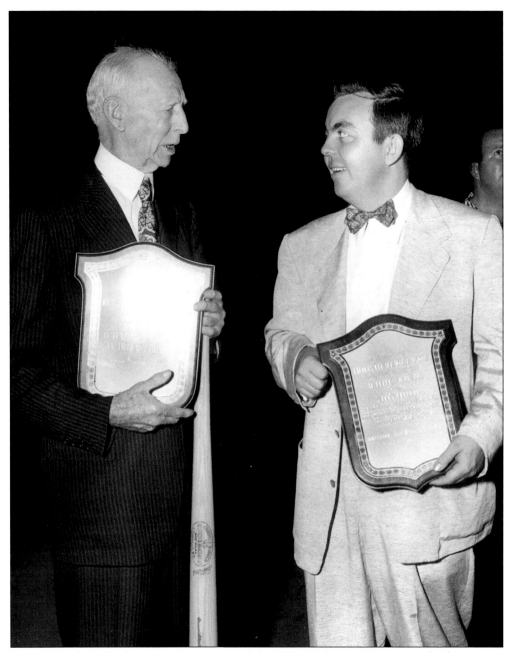

Connie Mack (left), the majestic manager of the Philadelphia Athletics, was the lone major league manager who dressed for games in a suit rather than a uniform. Mack started playing as a catcher but was better known for managing. He was first at Pittsburgh then Milwaukee, but beginning in 1901 headed the Athletics for half a century until he was 88 years old. In 1910 through 1914 his teams won four pennants and he took three in succession in 1929 to 1931. Born in Massachusetts in 1862, he was elected to the National Baseball Hall of Fame in 1937. Mack was one of many baseball greats brought to Wichita and the NBC tournament by Dumont who honored them for their contributions to the game while using their names to help fill seats. (Photo courtesy National Baseball Congress.)

Stepping to the microphone to accept an NBC tournament honor, one of the most colorful—and for a time, one of the most successful—pitchers ever, Dizzy Dean, left. Confident to the point of brashness, he joined the St. Louis Cardinals in 1932 and averaged 24 victories a year in the first five seasons. Often speaking of "me and Paul," referring to his brother, Dizzy won 30 games in 1934, and Paul, a rookie, added 19 more. The Cardinals—called "the Gashouse Gang"—rolled to a World Series victory over Detroit. In four different years Dean led the league in strikeouts and his single game record of 17 was the National League record. In 1937 Dean was struck on the toe by a batted ball while pitching in the all star game. The pain forced him to change his delivery which in turn injured his arm and brought his career to an early end. Born in Arkansas in 1911, Dizzy became one of the early athletes to turn sportscaster. He continued his colorful life, inventing a vocabulary that included words like "slud" as past tense for "slide." He died in 1974. (Photo courtesy National Baseball Congress.)

Well past his prime, John "Honus" Wagner swings at a ball before an NBC tournament game in 1954. After a sporting goods store he owned with Pie Traynor failed during the Depression, Wagner became the first commissioner of the National Baseball Congress, recruited by Hap Dumont with help from Fred Clarke, Wagner's former manager. Wagner is thought by some to be the greatest all-around player in history. Playing on Pittsburgh teams managed by Clarke, Wagner led the National League in hitting eight times during a 17-year career, was considered one of the best infielders of his time, and stole over 700 bases, leading the league six times. Sam Crawford called him, "the greatest ballplayer who ever lived in my book." Wagner was in the first group elected to the National Baseball Hall of Fame. He died in 1955, not long after this photo was taken. (Photo courtesy National Baseball Congress.)

Native Kansan Joe Tinker came home in 1944 as a coach for the Orlando, Florida, Army Air Field team which finished second in the NBC tournament. Tinker brought plenty of experience with him. He had managed the Cincinnati Reds, the Chicago Federals, and finally, the Cubs. Tinker was best known as part of the immortal double play trio of Tinker to Evers to Chance. The shortstop of the three, he also had playing credentials to go with his fame from the song. He was only 21 when he became the Cubs' regular shortstop, led National League shortstops in fielding five times, and helped win five pennants. Born in Muscotah in 1880, he died in Orlando in 1948. Two years before his death he was elected to the National Baseball Hall of Fame. (Photo courtesy National Baseball Congress.)

Joe E. Brown, right, was everything Raymond Dumont liked—a circus clown, a semipro baseball player, and a great fan of the sport. Known for his wide-mouthed smile, Brown had been a circus tumbler, a vaudeville performer, aBroadway actor, and a film star. One of the biggest movie stars of the '30s, in 1932 he combined his careers and loves by starring in a film called "Fireman, Save My Child," portraying a firefighter who also played baseball. He had written into his contract with Warner Brothers that he would have his own team at the studio and play with them when he was able. As a friend of Dumont's, he appeared at NBC events when his career permitted. During WW II he spent a great deal of time entertaining troops. Shown with him are former baseball commissioner A. B. Chandler, left, and J. G. Taylor Spink, publisher of *The Sporting News*, another friend of Durmont's. (Photo courtesy National Baseball Cogness.)

George Sisler succeeded Honus Wagner as commissioner for the National Baseball Congress, adding another title to his glittering baseball credentials, and traveling frequently to Wichita. Speaking at the dedication of Lawrence Stadium, Sisler explained that semipro baseball thrived in Kansas because the state has many farmers and "farmers like baseball." A first baseman, Sisler hit .407 and .420 in 1920 and 1922 and recorded 257 hits in 1920, still a major league record as of 2004. George also led the American League in stolen bases four times, prompting Ty Cobb to describe him as "the nearest thing to a perfect ball player." He was elected to the National Baseball Hall of Fame in 1939. Sisler played with the St. Louis Browns from 1915 until 1928 when he went to the Washington Nationals and the Boston Braves in the same summer, finishing his career in 1930. His lifetime batting average was .340. (Photo courtesy National Baseball Congress.)

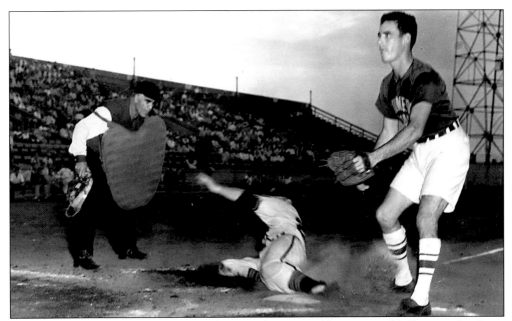

Not all players wear the traditional uniform. Looking more like picnic softball attire, the shorts were the uniform worn in the 1953 tournament by the Guam Marines. Here Jimmy Horn of Casa Grande Arizona, slides home as Webb, a pitcher for Guam, attempts to cover the play at home. The umpire is Jim De Santo. The Brooklyn Dodgers also experimented with shorts for themselves and their farm clubs but discarded the idea. (Photo courtesy National Baseball Congress.)

Known as the "clown prince of baseball," Al Schacht was a three-year major league pitcher and 15-year coach before becoming a full-time baseball clown and making a small fortune. In Wichita he also directed the band at the NBC. "I have become a household name," he once said. "When I enter a town, a courier gallops through the streets and shouts, 'Hey, girls—Al Schacht's in town.'" A teammate once said Schacht could "make a corpse laugh." He performed every fall at the World Series, traveled with USO shows to entertain troops, and became a successful New York restaurateur. (Photo courtesy National Baseball Congress.)

Ernest Quigley was involved in baseball at every level. As a National League umpire, he helped officiate the infamous 1919 Black Sox series, one of six he worked. Quigley coached in Kansas high schools and colleges, managed in the minor leagues, including Salina in the Central Kansas League, and ended his career by serving as athletic director at the University of Kansas from 1944 to 1950. At St. Mary's College, he coached Claude Hendrix who was later a Fairmount College and big league star. The NBC honored Quigley for helping increase activity on the nation's sandlots. (Photo courtesy National Baseball Congress)

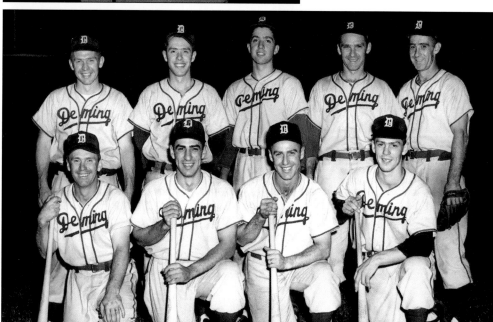

A true band of brothers—or at least a team of them—nine Zenders played for the Deming, Washington, Loggers and took the team to the finals of the 1956 NBC tournament before losing to usual-winner Fort Wayne, Indiana. Here, from left to right, with their ages and positions are: (front row) Pete (34, outfield), Jake (23, outfield), Nick (28, third base), and Dan (21, outfield); (back row) Lawrence (25, pitcher), John (27, outfield), Jim (16, catcher), Dick (33, manager-catcher), and Bernie (32, second base). (Photo courtesy National Baseball Congress.)

Old teammates reunite at a dinner in Wichita. Native Kansan Fred Brickell, right, talks with Lloyd "Little Poison" Waner about the years they played together in the Pittsburgh outfield. The other outfielder was Paul "Big Poison" Waner. Both Waner brothers are members of the National Baseball Hall of Fame. Brickell was with the Pirates from 1926 until 1930 when he moved to the Philadelphia Phillies. Over eight years he hit .281. Brickell's son. Fritz, played parts of three seasons for the Yankees and Angels but died of cancer at age 30. (Photo courtesy National Baseball Congress.)

A.B. "Happy" Chandler, former Kentucky governor and U.S. senator, was another friend of Ray Dumont's who was often in Wichita as a part of NBC activities. In this photo Hap is interviewed for local radio. Chandler followed Judge Kennesaw Mountain Landis as baseball commissioner, serving six years in a turbulent time that included the integration of baseball and monopoly charges leveled against major league baseball. Always expressing a strong concern for the players, he was sometimes called "the players' commissioner." (Photo courtesy National Baseball Congress.)

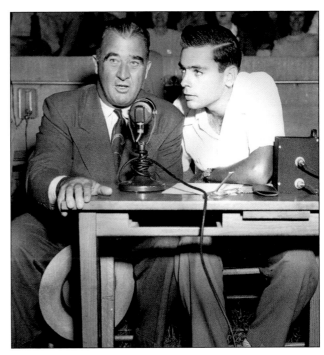

Johnny Antonelli starred for a Fort Meyer, Va., team that won the NBC championship in 1952 and produced one of the best pitching match ups in NBC history. He opposed former Wichita Indian and Yankee ace Bob Turley who was pitching for Brooke Army Medical Center of San Antonio, Tex. Both gave up five hits, but Antonelli had more help from teammates and won the game 3-1. Antonelli won 126 games in 12 big league seasons with the Braves, Giants, and Brewers. In 1954 his 21-7 record and 2.30 earned run average were the best in the major leagues. He also won a World Series game with the Giants. Besides the military team, Calderone also caught Antonelli in Milwaukee. Calderone had a .291 major league batting average. (Photo Courtesy National Baseball Congress.)

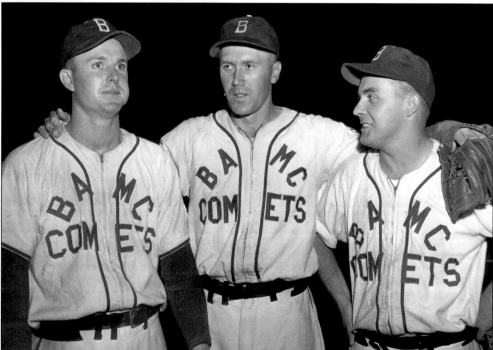

These three major leaguers bolstered the chances of Brooke Army Medical Center in the 1953 national tournament. At center is Bobby Brown, one of baseball's most remarkable players. He hit .300 his first two years with the New York Yankees where he spent his eight-year career and was a hitting star in four World Series. Brown became a physician and surgeon, retiring from baseball in 1954. Thirty years later, he left medicine to become president of the American League. Flanking him are Dick Kokos, a five year outfielder with the Browns and Orioles, and Owen Friend, an infielder who played with the Browns, Tigers, Red Sox, and Cubs after his Army service. Bob Turley, one of New York's best pitchers, was also a member of the BAMC team.(Photo courtesy of the National Baseball Congress.)

Daryl Spencer, second from left, had one of the finest major league careers of any native Wichitan. An infielder, he played 10 years with Giants, Cardinals, Dodgers, and Reds, then went to Japan for five years before retiring to Wichita. He was also a fixture on area semi-pro teams including the Boeing Bombers, where he played while stationed in the Army at Fort Sill, Oklahoma. During one national tournament, Spencer would play an afternoon game for the military team, fly to Wichita for a game at night, take a post-game train to Duncan, Oklahoma, and finally hitch hike back to Fort Sill for roll call the next morning. (Photo courtesy National Baseball Congress)

Rick Monday played 19 seasons for three major league teams and once, while a student at Arizona State University, played for Fairbanks, Alaska in the 1964 NBC tournament. He became part of baseball lore April 25, 1976 with the Chicago Cubs in Dodger Stadium in Los Angeles. Two protesters ran on the field, trying to ignite an American flag which Monday took from them, saving it from the fire. The 6-foot-3, 200-pound outfielder later returned to Los Angeles as a Dodger, then remained as a radio broadcaster. (Photo courtesy National Baseball Congress.)

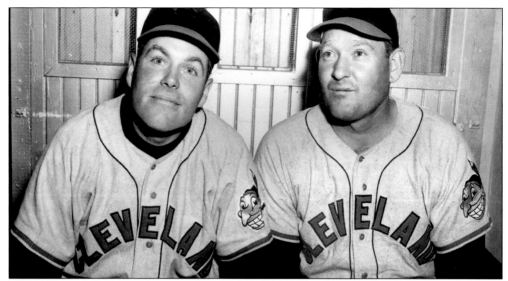

Dale Mitchell, left, was one of the American League's leading hitters in the early years after WW II with Cleveland but earlier was a member of the Beech Flyers in Wichita. The University of Oklahoma athlete spent most of his 11-year career in the majors with Cleveland. Although he hit over .300 seven times, Mitchell played his final 19 games with the Brooklyn Dodgers and may be best remembered as the man who struck out for the final out in Don Larsen's 1956 perfect game, the only one in World Series history. At right is Al Benton, a veteran of 14 major league seasons with the Athletics, Tigers, Indians, and Red Sox. Benton pitched with wartime military teams in the NBC tournament. (Photo courtesy National Baseball Congress.)

Bobby Bragan was one of the first NBC graduates to move into the major leagues. Playing for Gadsden, Alabama, in the first NBC tournament game ever held, Bragan joined two others from that season as big leaguers—Satchel Paige and Clay Smith of Cambridge, Kansas. Bragan was with the Philadelphia Phillies by 1940. After seven years in the majors, he became a player-manager in the Texas League to make room on the Brooklyn roster for Roy Campanella. Bragan also managed the Pirates and Indians and was the Atlanta Braves' first manager. (Photo courtesy National Baseball Congress.)

Roger Clemens was considering retirement after the 2003 season, but by 2004 he was putting on the uniform of the Houston Astros, starting life anew in the National League. Clemens is a former Hutchinson Bronco, pitching there the year before Barry Bonds arrived. In the American League he won 310 games, losing only 60 in a 19-year career. Twice, Clemens was named Most Valuable Player and he is a six-time Cy Young Award winner. (Photo courtesy Houston Astros.)

Ron Guidry is fourth on the New York Yankee's all time list with 170 victories. But in two NBC tournaments he failed to win a game. Called "Gator" for his home state of Louisiana, Guidry appeared in the NBC with a Louisiana team in 1972 and Liberal in 1973. His greatest major league streak came between the 1977 All Star game through the following summer when he won 35 games while losing just five. In 1978 he was the Cy Young winner and set the Yankee club strikeout record with 248. (Photo courtesy National Baseball Congress.)

Later called "The White Rat," Whitey Herzog contended he hit the longest home run at Lawrence Dumont Stadium. The ball, he said, landed on a passing train and rode it to California. Herzog came to Wichita with Fort Leonard Wood in 1953 and Springfield, Missouri, in 1954. After playing seven years for the Senators, A's, Orioles, and Tigers, he began a brilliant managerial career with the Rangers, Angels, Royals, and Cardinals, leading teams to first or second place in nine different seasons. Later, as general manager of the Cardinals, he brought Willie McGee, Ozzie Smith, and Bruce Sutter to Saint Louis. (Photo courtesy National Baseball Congress.)

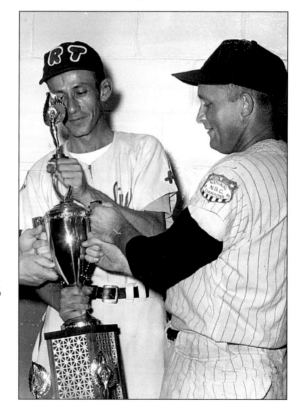

For parts of three seasons, John O'Donnell pitched in Wichita with the Indians, compiling records of 2-0, 14-16 and 11-15. He was on the league all-star team in 1953, but he retired from the professional game, went to work for the post office, and became a fixture on city semipro teams, including the often potent Wichita Dreamliners. (Photo courtesy National Baseball Congress.)

Dave Winfield was one of baseball's most gifted athletes. Drafted from the University of Minnesota in football and basketball, he chose baseball, where he pitched and played the outfield. Winfield was already a growing legend when he appeared in the NBC with Fairbanks, Alaska in 1972. A year later, he was with San Diego, starting a 22-year major league career with the Padres, New York Yankees, California, Toronto, Minnesota, and Cleveland. He also played in two World Series. Winfield was 7th on the all-time list in total games played when he retired and sixth in number of times at bat.

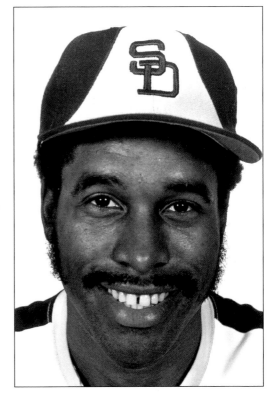

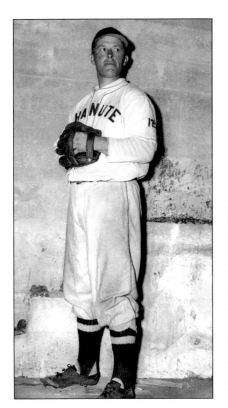

If nothing else, Claude Willoughby led the National League in odd nicknames. He was known as "Flunky" and "Weeping Willie" during his seven years in the National League, the first six with Philadelphia, the last with the Pirates. Here Willoughby is getting ready to pitch in the NBC state tournament for Chanute. Willoughby won 38 big league games, but lost 58, his best output coming in 1929 when he was 15-14. His main problem was control; he walked twice as many as he struck out. He led the league in free passes, with 108 in 1929. Willoughby was born in Buffalo and died in McPherson. (Photo courtesy National Baseball Congress.)

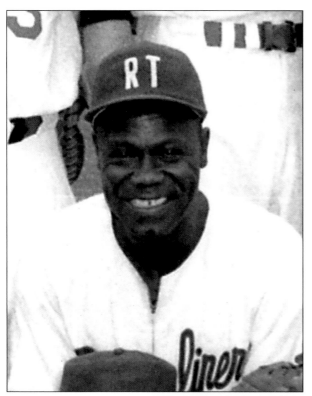

A coach saw Bobby Boyd's line drives and nicknamed him "Rope." Boyd was a Negro League all star with Memphis, and, in 1950, the first black player signed by the Chicago White Sox where he played parts of the 1951-54 seasons. In 1956 Boyd joined Baltimore, became a regular, and hit above .300 four times in five seasons, before finishing his career with Kansas City and Milwaukee. A first baseman, he joined the Rapid Transit Dreamliners and became the NBC tournament Most Valuable Player. He scouted and stayed in Wichita after retiring from the bus company. (Photo courtesy National Baseball Congress.)

Raymond Dumont recognized the value of publicity whether local or national and went to great lengths to be certain tournament games were aired across the country. Al Hefler, nearest camera, veteran play-by-play announcer for baseball, was among those Dumont brought to Wichita to talk about the tournament, in his case over the Mutual Radio Network, which carried major league games. In 1952 Hefler described the game between Merrill, Wisconsin, and Atwater, Calififornia, to his national audience. (Photo courtesy National Baseball Congress.)

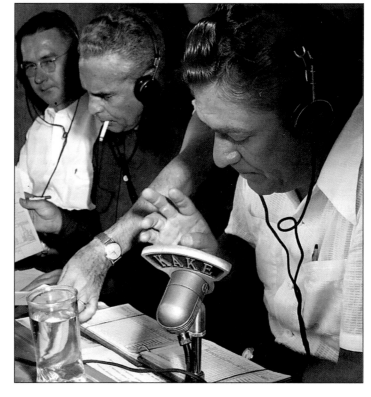

Taiwanese and California players line the base paths to open the 2003 NBC tournament while the Star Spangled Banner is played. The Taiwanese National team, from Taipei, brought the tournament to a non-American finish, becoming the first international team to win. Above, Chinese fans wave a Taiwanese flag in support of their team as it opened tournament play.

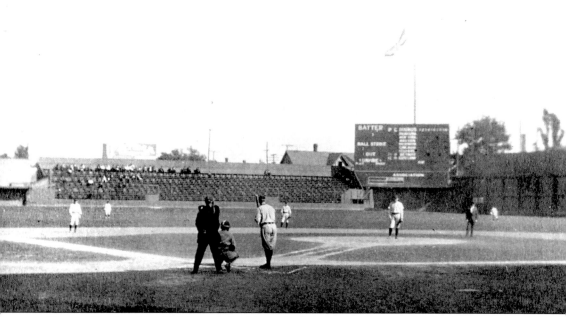

Former Shocker Lloyd Bishop pitched in only three games for a total of eight innings in his big league career with the Cleveland Indians. But on April 9, 1914, he faced Ty Cobb, one of the greatest players of all time. Bishop played both football and baseball for Fairmount College and a football injury was blamed for shortening his career on the diamond. He was the second Shocker pitcher to play for a big league team. After his retirement Bishop returned to south central Kansas where he became a successful banker. (Photo courtesy Wichita State University Libraries Special Collections.)

FIVE

Baseball Can Sometimes Be a Shocker

Ted Bredehoft is a small man, a one-time collegiate wrestler in Arizona. If Raymond Dumont of the National Baseball Congress ever had a competitor as a Barnum-like sports promoter, this former Wichita State University athletic director had to be it. Charged with energizing the Shockers' sports attendance, Bredehoft introduced camels, fireworks, and high decibel music to WSU football games. On one memorable night, smoke from his opening fireworks hung so heavy over the semi-depressed football field that the game had to be briefly delayed.

Bredehotft's best move, however, had to do with personnel rather than promotion. It was he who persuaded a young Oklahoma University baseball assistant to take a cut in pay and come to Wichita to head the Shockers' latest attempt at collegiate baseball play.

While relationships between the two men eventually cooled, to say Stephenson's hiring was successful is to put it lightly. Gene Stephenson, after his first 27 years as WSU coach, had won more collegiate baseball games than any other NCAA Division I coach except one. He had been ranked one of the country's top 10 coaches by *Baseball America* and by a poll of major league scouting directors. His teams have qualified for NCAA post-season play twenty-two times. Once, in 1989, the Shockers captured the collegiate championship.

Of course, college baseball was not born in Wichita with Stephenson, nor in the 20th century for that matter. Fairmount College, the predecessor to WSU, faced Southwestern College at Winfield in a debate-baseball doubleheader on April 14, 1899. They split, the Moundbuilders taking the baseball game and Fairmount the debate. Ironically, years later Southwestern would become national debate champion and Wichita would win a national baseball crown.

Two major league players got their starts in the early years of Shocker baseball. Claude Hendrix, a spitballing pitcher, was the more successful, playing eight years in the National League and twice leading it in win percentage. Lloyd Bishop, his career shortened by a football injury in college, played for Cleveland in 1914, then returned to Kansas and a banking career.

Across town, Friends University was matching Fairmount in big league alumni and bettered the Shocks in championship level play in the early years. The Quakers were state collegiate champions in 1916. Bill McGill went on to pitch for the St. Louis Browns in 1907, the first Wichita area collegian to become a major league player. Tex Jones, of Marion, reached the White Sox briefly in 1911, the second to arrive from a Wichita campus.

It was a gentle time for playing ball. In 1904, a game between Friends and Southwestern was called early with the Quakers leading, 9-6. *The Eagle* explained, "Owing to the desire of the Winfield students to catch the Santa Fe five o'clock train for home, but seven innings of the game were played."

Although WSU baseball started badly in its debate-baseball split with Southwestern, by 1901 it was posting winning records, 7-4 in that season. In 1903 the Shockers again met Southwestern, losing 1-0 in 15 innings. A century later that game was still tied for the longest in school history.

Fairmount maintained a winning momentum through 1906 then endured a series of up-and-down seasons. The worst came in 1910 when it went winless in six games with Northwest Oklahoma, Chilocco Indian School, Southwestern, and the Enid Browns. Its lone "moral victory" was its 2-0 loss to the Browns. The 1915 season was little better, the Shockers earning a 1-5-1 record. In 1918, however, the final record was 1-0, Fairmounts's lone game a win over Friends. One year later, Fairmount garnered another perfect finish, beating, in the only game it played, Wichita High School, 2-1.

From 1923 until 1948 there was no baseball at 21st and Hillside. It resumed again in 1948, then was dropped once more in 1970, remaining in limbo until Stephenson came aboard. Post WW II coaches included Lyle Sturdy, Ken Gunning, Dick Miller, Forrest (Woody) Jensen, Jerry Bupp, Ray Morrison, Lanny Van Eman, Verlyn Anderson, and John Saabs.

It was not until after WW II that Wichita State, then called the University of Wichita, again sent a player to the majors. Don Lock, who played basketball as well as baseball at WU, played eight major league seasons after his college career and managed minor league teams for two others. An outfielder, Lock was with Washington, Philadelphia, and Boston after finishing his collegiate career in 1958. Dick Sanders, who was a football quarterback, a basketball guard, and a baseball shortstop, played eight years in the New York Yankee and Brooklyn Dodger systems but never made it to the majors.

Wichita did once host the national college baseball tournament. In 1949, the third college World Series was played in Lawrence Stadium, producing a reluctant champion in the University of Texas. (Reluctance may be a Texas tradition. After losing the 2004 collegiate championship series to Cal State-Fullerton, Texas did not appear for the post-game awards ceremony.) Newspaper reports indicate that the Longhorns preferred not to play because their roster was depleted by injuries and players were in a hurry to get to summer jobs. Still, on June 25th, they beat Wake Forest 10-3 in the finals...while a husband was literally beating his wife in the stands. Police took the woman to St. Francis hospital, and the man to the police station while the game continued. Smaller then than it later became, the championship series featured teams from St. Johns, Wake Forest, Texas, and the University of Southern California. Wake Forest ousted defending champion USC in a 12-inning 2-1 victory before succumbing to Texas.

As had the two previous tournaments, the Wichita tourney lost money. The first, in Kalamazoo, Michigan, had only two teams. The second, in Denver, had four. But Wichita's event cost more than the others, in part because three of the teams flew to the city. Even though newspaper accounts indicated that the NCAA wanted to return the championship to Wichita the following year, it moved it to Omaha instead. There it remains, drawing some 260,000 fans annually with a $33.8 million a year economic impact on the city.

Two Texas players from the Wichita tournament did reach the major leagues. Altoona, Kansas, native Tom Hamilton, who played at Arkansas City in the summers, was Texas' first baseman and most valuable player of the tournament, hitting three homeruns and batting .500. But in 1952 and 1953 with the Athletics, he hit only .197 with no home runs. Murray Wall, the tournament's top pitcher, played with the Braves, Red Sox, and Washington, winning 13 games but losing 14.

Wichita State is not the only college in the region to have captured national attention. Cowley County Community College at Arkansas City has won national crowns twice under the leadership of Dave Burroughs. Cowley also produced two major league players, Junior Spivey and Travis Hafner. Still, the college spotlight in the region has been on WSU. The sport had been gone for eight years when Bredehoft brought Stephenson to town. From the beginning, the new coach was a winner, taking 43 in the first season even without benefit of a home field until the season nearly ended.

Even then, the WSU "home field" wasn't much. While it had a new Astroturf infield and an electronic scoreboard, there was no stadium or other facilities. In 1979 dugouts were constructed, and in 1983 a 320-seat bleacher stadium was installed. In 1985, the first true stadium went up,

with aluminum grandstands purchased from a World's Fair in New Orleans. Lights, clubhouse, locker rooms, offices, and other facilities were also added. By 1992 the park had the nation's largest on-campus scoreboard and construction continued, bringing the complex to its 21st century configuration. Apparently, investement and development spell success. WSU has won 889 home games since 1978 while losing only 204 and tying one.

While the earliest teams had little in the way of physical facilities, the momentum was there. Joe Carter, one of the greatest players in team history, was a freshman that second season. He went on not only to become an all-American, WSU's first, but to a 15-year major league career of near Hall of Fame proportions. By the Stephenson's third season, the team qualified for the NCAA post season playoffs.

In 1988 the Shockers beat Oklahoma State twice in the championship games of the NCAA regional and qualified for the College World Series, a sweet victory, as the Cowboys had inflicted five of Wichita State's 10 worst losses on the team. In 1989 the Shocks won the national title in a game that featured one of the grittiest performances ever by an athlete. First baseman Bryant Winslow entered the title game with a stress fracture in his leg, but played until the sixth inning when a collision broke his fibula and wrist. He tried to remain in the game, but the pain and lack of mobility forced him to retire. The Shockers went on to a 5-3 championship win over Texas.

A decade later, in 1999, the program endured one of its bleakest moments. The team's best pitcher, Ben Christensen—the best of all time, based on a career 21-1 record, in fact—threw a warm-up pitch that hit Evansville's Anthony Molina in the left eye while he waited to hit. Christensen, a junior from Goddard, was suspended for the remainder of the season, damaging Shocker hopes for playoff success. Brent Kemnitz, pitching coach, was suspended for the final 14 games of the regular season plus any post-season games involving Evansville. Christensen's suspension was believed to be the longest ever given by the NCAA, a decision it reached after eight days of investigation and deliberation. Christensen was drafted in the first round by the Chicago Cubs in 1999.

Facilities are now another Shocker strength. WSU's home field is rated one of the best collegiate baseball facilities in the nation. Seating almost 7,000, Eck Stadium has been rated as the sixth best in the nation—in a tie with Hawaii—in a *Baseball America* poll of college coaches, and seventh best in a similar ranking by sports information directors. The most recent improvements were completed in 2000.

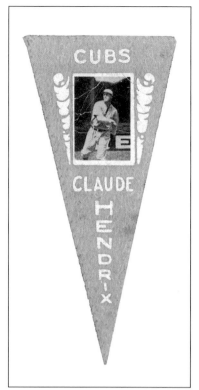
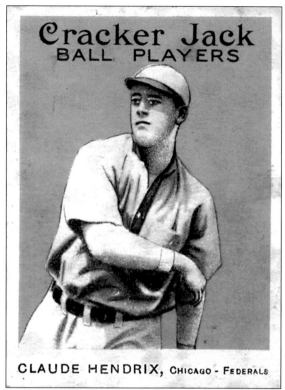

Claude Hendrix was the most successful former Shocker pitcher and one of the best to call Kansas home. Raised in eastern Kansas where his father was a banker and sheriff of Johnson County, Hendrix pitched 10 years for Pittsburgh and Chicago in the National League and in the Federal League's Chicago entry, with a career earned run average of 2.65. In 1912, his first full season, Hendrix won 24 and lost just five. He was an outstanding hitter, ending Babe Ruth's record-setting string of scoreless World Series innings pitched at 29 2/3 with a pinch hit single. Hendrix was said by some to have been banned from baseball, allegedly for planning to fix a game for gamblers. Solid proof has never been offered. (Card and pennant courtesy Wichita State University Libraries Special Collections.)

Early in the 2004 season, the Shockers won for the 1,428th time under coach Gene Stephenson, moving him into second place on the all-time collegiate victory list, ahead of Texas' Cliff Gustafson, but behind Augie Garrido, also of Texas, who has coached nine more years. WSU had been without baseball for nine years when Stephenson was hired to revive its diamond fortunes. His teams have won at least 40 games every season and have advanced into NCAA post-season play 21 times, winning the national championship in 1989. Three-time national coach-of-the-year, Stephenson not only put together a premier team, but an outstanding stadium and facilities were built under his direction.

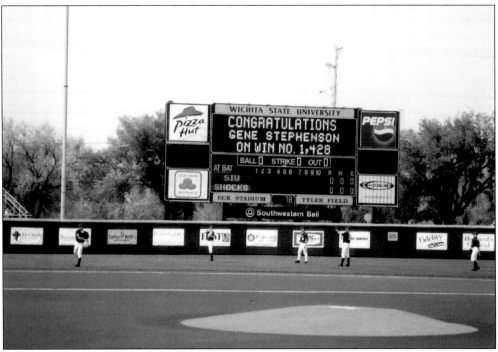

WSU's scoreboard is the largest in the nation at a collegiate ball park. Here, it congratulates Coach Stephenson on his landmark 1,428th win, moving him into second place on the all-time wins list.

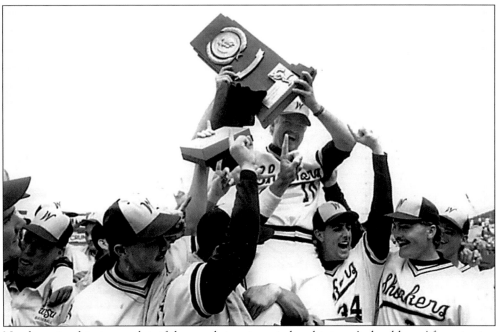

No championship is complete if the coach is not carried on his team's shoulders. After winning the NCAA title at Omaha in 1989 the team lifted coach Gene Stephenson skyward, where he hoisted the championship trophy. WSU defeated the Texas Longhorns 5-3 in the final game. (Photo courtesy Wichita State University.)

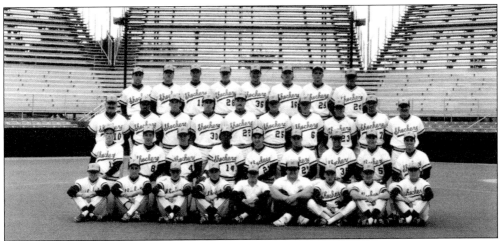

This 1989 team won the College World Series in Omaha. Pictured are, from left to right: (front row) Tony Mills; Charlie Giaudrone; Jim Audley; P.J. Forbes; Randy Fox, assistant trainer; Darin Kerr, student trainer; Steve Smith; Mike Jones; Pat Meares; (second row) Tommy Tilma; Jeff Bonacquista; Mike Blankenberger; Joe Wilson; Paul Cheatum, Greg Brummett; Morgan Le Clair; Mike Lansing; Jay Haffley; (third row) Gene Stephenson; Guy Goodman; Todd Dreifort; Brian Buzard; Eric Wedge; Jeff Bluma; Mike McDonald; Mike Wentworth; Craig Marshall; Loren Hibbs, assistant coach; (back row) Jim Newlin; Kevin Lanterman; Bryant Winslow; Tyler Green; Scott Mart; Jeff Williams; Darrin Paxton; Brent Kemnintz, pitching coach. The Shockers came out of the loser's bracket to defeat perennial power Texas 5-3 in the finals. WSU had beaten Arkansas, lost to Florida State, defeated Arkansas again, then beat the Seminoles twice en route to the championship game. (Photo Courtesy Wichita State University.)

President George H. W. Bush, a first baseman at Yale University, became an honorary Shocker after WSU's victory in the 1989 College World Series. Wichita State players and coaches were guests at the White House following their historic victory in Omaha, the first national championship for the program. Ironically, WSU defeated the team from the president's home state of Texas for the championship. (Photo courtesy Wichita State University.)

Bryant Winslow was the Shockers' first baseman in 1989 and finished the season with a stress fracture in his leg. In the final game against Texas, he collided with a base runner, breaking his fibula and his wrist as well. Still, he stayed in the game, finally realizing that his lack of mobility would hurt the team's chances and removing himself. He was confined to a wheel chair but made it to the team's victory celebration. (Photo Courtesy Wichita State University Libraries Special Collections.)

Fairmount University's second major league player arrived in the big leagues in 1914. It wasn't until 1962that the team boasted a third, Don Lock. Both a basketball and baseball player at Wichita University, Lock was named to the all-Missouri Valley team in baseball twice before signing a professional contract and debuting in Washington with the Senators. He played there until 1967, moving to the Phillies and then on to the Red Sox for his final season in 1969. He was a regular outfielder for most of his big league years. After playing, he managed minor league teams for two seasons. (Photo courtesy Wichita State University)

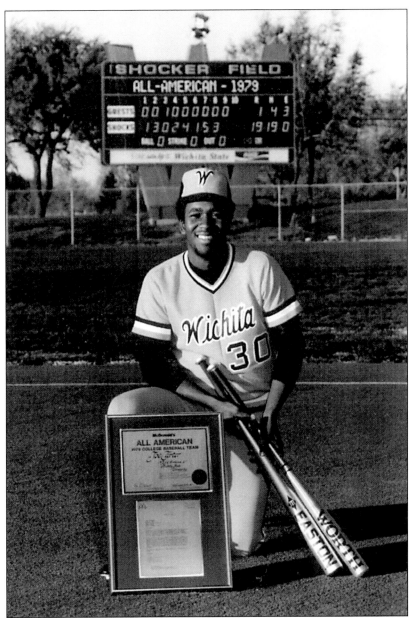

The first true star of the Gene Stephenson era came from the coach's own hometown, Guthrie, Oklahoma. Arriving at WSU to play football as well as baseball, Joe Carter reported in Stephenson's second season and led the nation with an .824 slugging percentage. Carter was national player of the year in 1981 and holds the Shocker career home run record. Playing in the NBC tournament with Boulder, Colorado, Carter is credited with the longest home run in tournament history. The ball traveled more than 900 feet in the air and on the ground. In 1983 he began a 15-year big league career. One of his most memorable moments was as a Toronto Blue Jay when his three run homerun in the ninth inning won the sixth and final game of the 1993 World Series. His best hitting season was in 1986 at Cleveland when he averaged .302. For his career he hit .260 with 396 home runs. He is fifth all-time in World Series home run hitting percentage. (Photo courtesy Wichita State University.)

Little brother Stephenson merited a hug from his coach when he was named to WSU's all quarter century team. Phil Stephenson, younger brother of coach Gene, didn't get his job because of nepotism. The younger Stephenson was named the college player-of-the-century by *Collegiate Baseball*. He set nine school offensive records, was twice an All-American, and once a second team Academic All-American. He went on to a four-year major league career and then managed and coached for minor league teams. (Photo courtesy Wichita State University.)

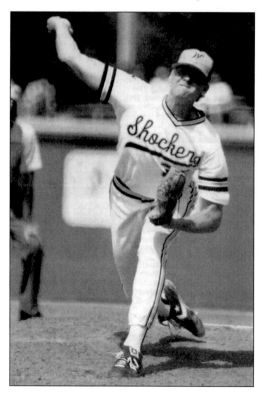

Darren Dreifort was the second pick in the 1993 free agent draft—behind Alex Rodriguez. He is tied for second on the Shockers' all-time list for fewest hits per nine innings pitched with 5.8. Dreifort's nine-year major league career, all with Los Angeles, has been hampered by injuries and corrective surgeries. His best major league season as a pitcher was in 1999 when he was 13-13. At WSU, Dreifort was named both relief pitcher and the designated hitter on the 25th anniversary all star team. His brother Todd was also named to the team. (Photo courtesy Wichita State University.)

(*above*) Two of the top baseball Shockers in history, Casey Blake and Braden Looper, were chosen for Team USA—the Olympic squad—in 1996. Looper went on to become one of the major league's best relief pitchers and, in 2003, with the Florida Marlins, the first Shocker pitcher to win a World Series game. He moved to the New York Mets for 2004 as the team's closer. Blake likewise became a major league regular as third baseman for Cleveland. In mid-2003 Blake was named the American League Player of the Week. (Photo courtesy Wichita State University.)

(*right*) Eric Wedge caught the final pitch for a strikeout in the Shockers' 1989 College World Series victory, but was limited to only 34 major league games by knee problems. He made the most of them, as a learning experience. In 2003, at age 34, Wedge became the youngest manager in the major leagues, taking over the Cleveland Indians after managing the Tribe's AAA farm club at Buffalo for two seasons. He was named the catcher on the team representing Gene Stephenson's first 25 years at WSU, having played at the university from 1987 to 1989. (Photo courtesy Wichita State University.)

WuShock, painted beside the diamond on Tyler Field, urges the Shockers on at all home games, as he does in this pre-game team rally. Usually called just "the Shockers," WSU's full name is the Wheatshockers, in honor of the state's largest crop. Wu (for Wichita University) Shock is a big-nosed, wide-eyed shock of wheat who appears at games and adorns uniforms, player caps, and other prominent spots where the school's teams play.

Russ Morman played a record 87 games for WSU and set the school record for runs batted in, then spent parts of nine seasons in the major leagues with the White Sox, Royals and Florida Marlins. But much of his baseball career was at the highest levels of the minor leagues. *Baseball America* named him the third best "minor league journeyman" for the decade of the 1990s. Usually a first baseman, Morman appeared in 207 major league games and hit .249. At WSU in 1983 and 1984 he was a second and third team All American. (Photo courtesy Wichita State University.)

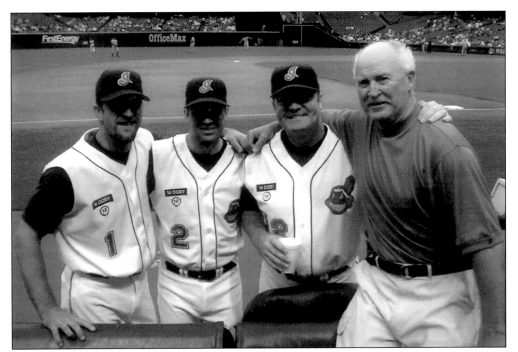

One little, two little, three little Indians... From left to right are Casey Blake, Zach Sorenson, and Eric Wedge—all former WSU stars—with the Cleveland Indians in 2003. Blake was the team's regular third baseman, Sorenson a utility infielder and Wedge the manager. With them is their college coach, Gene Stephenson. On the Indians' jersey is a patch memorializing Larry Doby, the first black player for Cleveland and in the American League. (Photo courtesy Wichita State University.)

Dick Sanders is one of the few WSU baseball players enshrined in the school's Pizza Hut sports hall of fame who did not reach the major leagues. Probably the most versatile athlete in WSU history, Sanders starred as the football quarterback, a guard on the basketball team, and the baseball shortstop during his collegiate career, then played in the minor leagues for nine seasons. After his retirement, he became a major college sports official. (Photo courtesy Wichita State University.)

Former Shocker Doug Mirabelli has made an excellent living catching knuckleballs. He arrived in the major leagues in 1996 and was still active in 2004, having played with San Francisco and Texas before joining the Red Sox. In Boston he has become the "personal catcher" for Tim Wakefield, one of the few successful big league pitchers throwing the hard to handle—for catchers and hitters—knuckler. With Boston his batting average has also improved, from a career .235 to over .300 in early 2004. His career .341 batting average ties him for 25th on the Shockers' all-time list. (Photo courtesy Wichita State University.)

Pat Meares was overlooked for many of WSU's post season awards, but the Salina native fashioned one of the most successful professional careers in Shocker history as a shortstop. He joined the Twins in 1993, then moved in 1999 to the Pirates. In 982 major league games he has hit .258. A hand injury hampered his career in later years. (Photo courtesy Wichita State University.)

Brent Kemnitz, has been with the Shockers for as many years as his boss, Gene Stephenson, although the first two were as a student assistant. Considered one of the nation's best college pitching coaches, he's sent 21 pitchers to the major leagues, 11 from WSU, and 10 more from Anchorage, Alaska, where he coached for the National Baseball Congress powerhouse, the Glacier-Pilots. He had a 21-7 pitching record at Phillips University in his native Oklahoma. At WSU he also coordinates recruiting and scheduling. (Photo courtesy Wichita State University.)

Jim Thomas was twice an All-America second baseman and held that position on WSU's all 25-year team. After nine years of professional play he joined WSU as a full-time coach in 1992. He primarily works on the team's defense and hitting, coordinates the strength and conditioning program, and is the first base coach during games. (In 2003 when Coach Stephenson was sidelined with an injury, he acted as third base coach for most of the season.) Thomas was a high school All-American at Wichita High school Southeast as a senior. (Photo courtesy Wichita State University.)

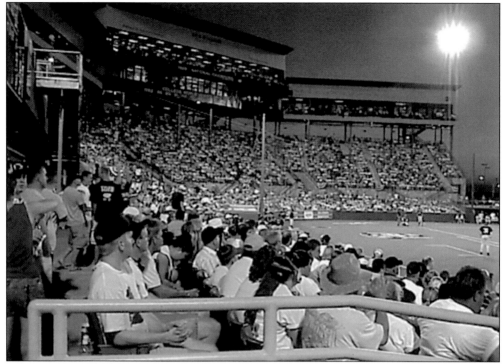

A capacity crowd fills Eck Stadium to root for the WSU ball club.

Tyler Green is the only WSU pitcher with a nine inning no-hitter, but pitched in the major leagues for only four seasons because arm injuries shortened his career. However, he was picked for the National League all star team in that period. From Denver, Green was the 10th overall choice in the 1991 free agent draft and won 18 games, losing 24, for Philadelphia from 1993 to 1998. He attempted a comeback in 1999 at Scranton in the International League, but was unable to return to the big leagues. (Photo courtesy Wichita State University)

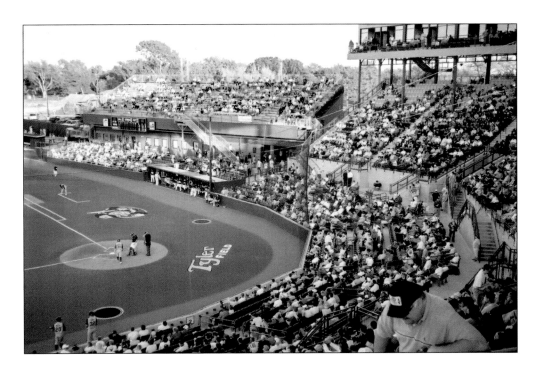

Eck Stadium opened in 1985, seating just 3,500, but has been expanded many times since, and as of 2004 could accommodate almost twice that many. The stadium has become the largest baseball facility in Kansas, slightly larger than Lawrence-Dumont Stadium in downtown Wichita. It is regularly ranked among the top 10 collegiate baseball facilities in the nation. (Photo courtesy Wichita State University.)

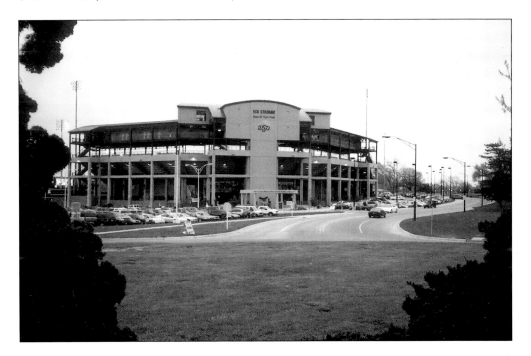

This fan obviously let baseball go to his—or her—head. Forced to begin play in cold weather due to WSU's northern location, the Shockers attract fans in spite of Polar-esque temperatures. Head gear, as well as warm coats, help.

There's no place like home—unless it's the outfield hill at Eck Stadium. These Wichita State University fans carried a sofa with them to soak up springtime sun during a Shocker game. Behind them is the Coleman Pavilion, designed for picnics and other group outings.

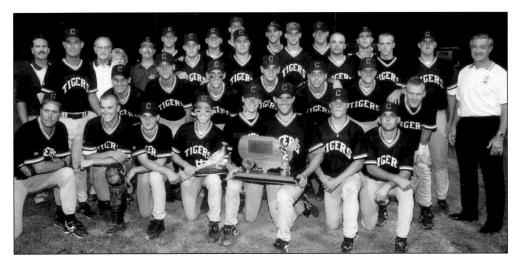

Cowley County Community College has a baseball tradition of its own, that in at least one way bests that of WSU. Twice, the college has won national championships. The Tigers, under coach Dave Burroughs, have been one of the nation's premier two-year college teams, producing major leaguers Junior Spivey and Travis Hafner. Pictured here are members of the 1998 NJCCA championship team, from left to right: (front row) Darren Burroughs, assistant coach; Casey Eckstein; Kyle Holland; Aaron Sanderholm; Justin Pirtle; Brian Carter; Tyler Osborne and Braden Dimmick; (second row) assistant coach Scott Hennessey; Brian Manwell; Kent Schaub; Josh McMillan; Sam Scott; Scott Hankins; Josh Taylor and Justin Helterbrand; (third row) Jamie Hamilton, assistant tournament director; unidentified; unidentified; Lee Young, tournament host; Luke Hocker; Dale Pearson; Clayton Soule; Grant Bergman; Brandon Robertson; Chris Wright; and tournament director Sam Suplezio; (fourth row) Aaron Akin; Cory Simpson; Curtis Guy; Travis Hafner; Travis Hughes; and Brad Kleeman. Below, the entire team seems to be signaling, "We're number one!" after winning the 1997 two-year college crown. (Courtesy Cowley County Community College.)

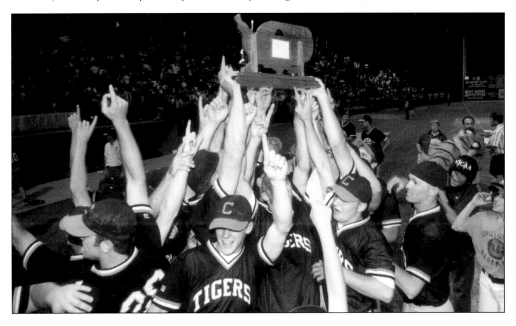

Appendix A
Wichita State All-Americans

Zach Sorenson	1998*	SS
Kennie Steenstra	1991	P
Mark Standiford	1988	2B
Phil Stephenson	1981–82	1B
John Tetuan	2002**	SP
Ben Thomas	1996**	P/DH
Jim Thomas	1981*–82**	2B
Travis Wyckoff	1996	P/OF
Eric Wedge	1989	C
Chris Wimmer	1991*–92**	SS

Academic All-Americans
(First, Second*, and Third** Teams)

Casey Blake	1994*–95	3B
Jeff Bluma	1990	P
Mark Bluma	1998-99*	P
Mike Drumright	1994**–95	P
Bryan Erstad	2003*	DH
Tim Gaskell	1983	OF
Charlie Giaudrone	1991*–92	P
Don Heinkel	1982	P
Mark Johnson	2003*	OF
Pat Magness	1998*	1B
Zach Sorenson	1998	SS
Kennie Steenstra	1991*–92	P
Phil Stephenson	1982*	1B

Shocker National Honors

Player of the Year: Joe Carter, 1981; Phil Stephenson, 1982
R. E. "Bob" Smith Award: Darren Dreifort, 1993
Golden Spikes Award: Darren Dreifort, 1993
NCAA Pitcher of the Year: Bryan Oelkers, 1982
NCAA Coach of the Year: Gene Stephenson, 1982, 1989, 1993
Collegiate Player of the Century: Phil Stephenson
National Academic Athlete of the Year: Charlie Giaudrone, 1992; Mike Drumright, 1995
College World Series MVP: Greg Brummett, 1989

Wichita State Major League Alumni

Name	Career	Major League Teams
Claude Hendrix	1911–20	Pittsburgh, Chicago F, Chicago, N
Lloyd Bishop	1914	Cleveland
Don Lock	1962–1969	Washington, Philadelphia, Boston
Bryan Oelkers	1983, 1986	Minnesota, Cleveland
Joe Carter	1983–1998	Chicago N, Cleveland, San Diego, Toronto, Baltimore, San Francisco
Charlie O'Brien	1985–2000	Oakland, Milwaukee, New York N, Atlanta, Toronto, Chicago, Anaheim, Montreal
Russ Morman	1986–1997	Chicago A, Kansas City, Florida
Don Heinkel	1988–1989	Detroit, St. Louis
Rick Wrona	1988–1994	Chicago N, Cincinnati, Chicago A, Milwaukee
Phil Stephenson	1989–1992	Chicago, San Diego

Jeff Richardson	1990	California
Eric Wedge	1991–1994	Boston, Colorado
David Haas	1991–1993	Detroit
Mike Lansing	1993–2001	Montreal, Colorado, Boston
Tyler Green	1993–1998	Philadelphia
Pat Meares	1993–2001	Minnesota-Pittsburgh
Greg Brummett	1993	San Francisco, Minnesota
Darren Dreifort	1994–Present	Los Angeles
Jamie Bluma	1996	Kansas City
Doug Mirabelli	1996–Present	San Francisco, Texas, Boston
Braden Looper	1998–Present	St. Louis, Florida, New York N
Kennie Steenstra	1998	Chicago N
P.J. Forbes	1998, 2001	Baltimore, Philadelphia
Casey Blake	1999–Present	Toronto, Minnesota, Baltimore, Cleveland
Nate Robertson	2002–Present	Florida, Detroit
Zach Sorensen	2003	Cleveland
Koyie Hill	2003	Los Angeles
Adam Peterson	2004	Toronto

Friends University Major League Alumni

Tex Jones	1911	Chicago A
Bill McGill	1907	St. Louis A

Cowley County Community College Major League Alumni

Travis Hafner	2002–present	Texas, Cleveland
Junior Spivey	2001–present	Arizona

Hutchinson Community College Major League Alumni

Brian Digman	2004–	Detroit

Appendix B
National Baseball Congress Champions and Finalists

Year-Champion	Runner Up	Year-Champion	Runner Up
1935 Bismarck ND	Duncan OK	1969 Anchorage AK	Liberal KS
1936 Duncan OK	Buford GA	1970 Grand Rapids MI	Anchorage AK
1937 Enid OK	Buford GA	1971 Anchorage AK	Fairbanks AK
1938 Buford GA	Enid OK	1972 Fairbanks AK	Liberal KS
1939 Duncan OK	Mt Pleasant TX	1973 Fairbanks AK	Liberal KS
1940 Enid OK	Mt Pleasant TX	1974 Fairbanks AK	Boulder CO
1941 Enid OK	Waco TX	1975 Boulder CO	Fairbanks AK
1942 Wichita Boeing	Waco TX	1976 Fairbanks AK	Anchorage AK
1943 Camp Wheeler GA	Enid AAF, OK	1977 Kenai AK	Fairbanks AK
1944 Sherman Field KS	Enid AAF, OK	1978 Boulder CO	Fairbanks AK
1945 Enid AAF, OK	OrlandoAAB, FL	1979 Liberal KS	Santa Maria CA
1946 St Joseph MO	Carmichael CA	1980 Fairbanks AK	Liberal KS
1947 Ft Wayne IN	Golden CO	1981 Clarinda IA	Liberal KS
1948 Ft Wayne IN	Elkin NC	1982 Santa Maria CA	Anchorage AK
1949 Ft Wayne IN	Golden CO	1983 Grand Rapids MI	Fairbanks AK
1950 Ft Wayne IN	Elk City OK	1984 Grand Rapids MI	Liberal KS
1951 Sinton TX	Atwater CA	1985 Liberal KS	North Pole AK
1952 Ft Myer VA	Ft Leonard Wood	1986 Anchorage AK	Grand Rapids MI
1953 Ft Leonard Wood	Wichita Boeing	1987 Mat-Su AK	Grand Rapids MI
1954 Wichita Boeing	Springfield MO	1988 Everett WA	Midlothian IL
1955 Wichita Boeing	Sinton TX	1989 Wichita Broncos	Grand Rapids MI
1956 Ft Wayne IN	Deming WA	1990 Wichita Broncos	Midlothian IL
1957 Sinton TX	Ft Wayne IN	1991 Anchorage AK	Kenai AK
1958 Drain OR	Alpine TX	1992 Midlothian IL	Liberal KS
1959 Houston TX	Elgin IL	1993 Kenai AK	Beatrice NE
1960 Grand Rapids MI	Ponchatoula LA	1994 Kenai AK	Wichita Broncos
1961 Ponchatoula LA	Grand Rapids MI	1995 Team USA	Hays KS
1962 Wichita Dreamliners	Fairbanks AK	1996 El Dorado KS	Tacoma WA
1963 Wichita Dreamliners	Ponchatoula LA	1997 Mat-Su AK	Nevada MO
1964 Wichita Glassmen	Fairbanks AK	1998 El Dorado KS	Nevada MO
1965 Wichita Dreamliners	Liberal KS	1999 Dallas TX	Kenai AK
1966 Boulder CO	West Point MS	2000 Liberal KS	Hays KS
1967 Boulder CO	Honolulu HI	2001 Anchorage AK	Hays KS
1968 Liberal KS	Jackson MS	2002 Fairbanks AK	Anchorage AK
		2003 Taiwanese Nationals	Santa Barbara CA

Appendix C
Major League Players
Born in the Wichita Region

The Pitchers	Birthplace	Year	Sea	W-L	ERA	Team
Jack Banta	Hutchinson	1924	4	14-12	3.78	Pit/Cin/PhiN
Clarence Beers	El Dorado	1918	1	0-0	13.50	StL/N
Lloyd Bishop	Conway Spings	1890	1	0-1	5.63	Cle
Tom Borland	El Dorado	1933	2	0-4	6.75	BosA
Greg Brummett	Wichita	1967	1	4-4	5.08	Det
Bob Cain	Longford	1924	5	37-44	4.50	ChiA/StLA
Clay Christiansen	Wichita	1958	1	2-4	6.05	NYA
Mardie Cornejo	Wellington	1951	1	4-2	2.43	NYN
Nate Cornejo(x)	Wellington	1979	3	11-26	5.14	Det
Jimmy Durham	Douglass	1881	1	1-1	5.85	ChiA
Darren Dreifort(x)	Wichita	1972	8	47-56	4.36	LA
Charles Faust	Marion	1880	1	0-0	4.50	NYN
Larry Foss	Castleton	1936	2	1-2	5.33	Pit/NYN
Ross Grimsley Sr	Americus	1922	1	0-0	3.86	ChiA
Fred Kipp	Piqua	1931	4	6-7	5.08	Bkn/LA/NYA
Paul Lindblad	Chanute	1941	14	68-63	3.28	KC/Oak/Tex
Del Lundgren	Lindsborg	1899	3	5-15	6.58	PitN/BosA
Ernie Maun	Clearwater	1901	2	2-5	6.19	NYN/PhiN
Bill McGill	Galva	1907	1	1-1	3.44	StLA
Larry McWilliams	Wichita	1954	13	78-90	3.99	Atl/Pit/StL/KC
Bill Phebus	Cherryvale	1909	3	3-2	3.31	Was
Ray Pierce	Emporia	1897	3	7-11	5.64	ChiN/PhiN
Nate Robertson(x)	Wichita	1977	2	1-3	6.45	Fla/Det
Charley Rhodes	Caney	1885	3	7-11	3.46	StLN/ChiN
Andy Rush	Longton	1925	1	0-1	9.31	Bkn
Roy Sanders	Stafford	1892	2	7-10	2.75	Cin/Pit
Roger Slagle	Wichita	1953	1	0-0	0.00	NYA
Josh Swindell	Rose Hill	1885	1	0-1	2.08	Cle
Fay Thomas	Holyrood	1904	4	9-20	4.95	NYN/Cle/Bkn/StLA
Hy Vandenburg	Abilene	1907	7	14-10	4.32	BosA/NYN/ChiN
Duane Wilson	Wichita	1934	1	0-0	5.68	BosA
Ralph Winegarner	Benton	1909	5	8-6	5.33	Cle/StlA

Position Players

	Birthplace	Year	Sea	BA	Pos	Teams
Nick Allen	Norton	1888	6	.232	C	BufF/ChiN/Cin
Beals Becker	El Dorado	1886	8	.276	OF	Pit/Cin/PhiN
Fred Brickell	Saffordville	1906	8	.281	OF	Pit/PhiN
Fritzie Brickell	Wichita	1935	3	.227	Inf	NYY/LAA
Johnny Butler	Fall River	1893	4	.252	Inf	Bkn/ChiN/StLN
Enos Cabell	Ft Riley	1949	15	.277	Inf	Bal/Hou/SF/Det/LA
Tony Clark(x)	Newton	1972	9	.268	1b	Det/Bos/NYN/NYA
Josh Clarke	Winfield	1879	5	.239	OF	LouN/StLN/Cle/BosN
Johnny Damon(x)	Ft Riley	1973	9	.284	OF	KC/Oak/Bos
Darren Daulton	Ark City	1962	14	.245	C	PhiN/Fla
Lee Dressen	Ellinwood	1889	2	.205	1b	StlN/Det
George Hale	Dexter	1894	4	.223	C	StLA
Tom Hamilton	Altoona	1925	2	.242	1b	PhiA
Gail Henley	Wichita	1928	1	.233	OF	Pit
Bob Horner	Jct. City	1957	10	.277	Inf	Atl/StLN
Tex Jones	Marion	1885	1	.266	1B	ChiA
Rod Kanehl	Wichita	1934	3	.241	I/OF	NYN
Don Lock	Wichita	1936	8	.238	OF	Was/PhilN/BosA
Bill Marriott	Pratt	1893	6	.266	Inf	ChiN/BosN/Bkn
Gene Mauch*	Salina	1925	9	.239	Inf	Bkn/Pit/ChiN/ BosN/StLN/BosA
Carl Manda	Little River	1888	1	.267	2b	ChiA
Ike McCauley	Wichita	1891	5	.246	Inf	Pit/StLN/ChiN
Pat Meares	Salina	1968	9	.258	Inf	Min/Pit
Herm Merritt	Independence	1900	1	.370	Inf	Det
Claire Patterson	Ark City	1887	1	.125	OF	Cin
Gaylen Pitts	Wichita	1946	2	.250	Inf	Oak
Ronn Reynolds	Wichita	1958	6	.256	C	NYN/PhiN/Hou/SD
Darryl Spencer	Wichita	1929	10	.244	Inf	NYN/SF/StlN/LA/Cin
Bob Swift**	Salina	1915	14	.231	C	StLA/PhiA/DetA
Danny Thompson	Wichita	1947	7	.248	Inf	Min/Tex
Bob Thurman	Wichita	1917	5	.246	OF	Cin
Gaylen Pitts	Wichita	1946	2	.250	Inf	Oak
Art Weaver	Wichita	1879	4	.183	C	StLN/Pit/StLA/ChiA
Mitch Webster	Larned	1959	13	.263	OF	Tor/Mon/ChiN/Cle/ Pit/LA

(x) Active as of 6/1/2004

Major League Players Born Elsewhere But Living in the Region at the Time of Death

Position Players	Residence at Death	Year	Seasons	BA	Pos	Teams
Tom Angley	Wichita	1952	1	.250	C	ChiN
Fred Clarke ***	Winfield	1960	21	.312	OF	LouN/Pit
Lu Clinton	Wichita	1997	8	.247	OF	BosA/CalA/ NYA
Gus Hetling	Wichita	1962	1	.143	IF	Det
Frank Isbell	Wichita	1941	10	.250	IF	ChiN/ChiA
Woody Jensen	Wichita	2001	9	.285	OF	Pit
Howie McFarland	Wichita	1993	1	.091	OF	Was

Pitchers	Residence at Death	Year	Sea	W-	ERA	Teams
Virgil Barnes	Wichita	1958	9	61-59	3.66	NYN/BosN
Lee Dashner	El Dorado	1959	1	0-0	5.40	Cle
Louis Durham	Bentley	1960	4	1-0	5.28	Bkln/Was/NYN
Art Evans	Wichita	1952	1	0-0	3.00	ChiA
Jack Harper	Halstead	1927	1	0-0	3.12	PhiA
Oscar Horstmann	Salina	1977	3	9-7	3.67	StLN
Ken Johnson	Wichita	2004	6	12-14	4.58	StLN/PhiN/Det
Archie McKain	Salina	1985	6	26-21	4.26	BosA/Det/StLA
Rufe Meadows	Wichita	1970	1	0-0	0.00	CinN
Red Phillips	Wichita	1988	2	4-4	6.42	Det
Willie Ramsdell	Wichita	1969	5	24-39	3.83	Bkn/Cin/ChiN
Chuck Rose	Salina	1961	1	1-2	5.40	StLA
Jug Thesegna	Wichita	2002	1	0-0	5.11	Was
Ted Welch	Great Bend	1943	1	0-0	6.00	StLF
Ed Willett	Wellington	1934	10	102-99	3.22	Det/StLF
Spades Wood	Wichita	1986	2	6-9	5.6	Pit

* In addition to playing, Mauch was a major league manager from 1960–82 and 1985–87
** In addition to playing, Swift was a major league manager in 1965–66; he also was the catcher for another native Kansan, Bob Cain, of Longford, when Bill Veeck sent to the plate 3' 7" Eddie Gaedel in 1953. Cain walked Gaedel who was removed from the game for a pinch runner and then banned from the major leagues for lack of playing ability.
*** In addition to playing, Clarke was a major league manager in 1897–1915 and was elected to the National Baseball Hall of Fame in 1945.

Wichita's Professional Teams

Year	League	Name	Affiliation	Finish	W	L	Manager
1887	KSL	Braves		1st	17	10	George Moid
1887	W L	Braves		10th	7	25	George Moid
Not in Professional Baseball							
1896	KS	Eagles		3rd	10	8	Harry McCloskey
Not in Professional Baseball							
1905	WA	Jabbers		1st	79	56	Wm. Kimmell
1906	WA	Jabbers		3rd	75	65	Wm. Kimmell
1907	WA	Jabbers		1st	98	35	Jack Holland
1908	WA	Jobbers		2nd	87	53	Jack Holland
1909	WL	Jobbers		5th	71	82	Jack Holland
1910	WL	Jobbers		4th	89	78	Frank Isbell
1911	WL	Jobbers		3rd	15	9	Frank Isbell
1912	WL	Jobbers		6th	75	79	George Hughes
1913	WL	Jobbers		8th	65	101	Charlie Babb
1914	WL	Witches		8th	63	102	George Graham
1915	WL	Wolves		7th	57	80	Ham Patterson
1916	WL	Woves		8th	53	85	Jimmy Jackson
1917*	WL	Witches		8th	33	59	Frank Isbell
1917**	WL	Witches		6tth	28	28	Joe Berger
1918	WL	Witches		1st	41	24	Joe Berger

1919	WL	Witches		3rd	75	65	Joe Berger
1920	WL	Witches		2nd	92	62	Joe Berger
1921	WL	Izzies		1st	106	61	Joe Berger
1922	WL	Izzies		3rd	94	73	Joe Berger
1923	WL	Izzies		3rd	100	68	Howard Gregory
1924	WL	Izzies		6th	79	88	Howard Gregory
1925	WL	Izzies		4th	80	84	Howard Gregory
1926	WL	Izzies		8th	58	108	Howard Gregory/ Pat Haley
1927	WL	Larks		2nd	91	63	Doc Crandall
1928*	WL	Larks		3rd	42	38	Doc Crandall
1928**	WL	Larks		2nd	52	32	Doc Crandall
1929	W L	Aviators		4th	77	79	Art Griggs
1930	WL	Aviators		1st	89	56	Art Griggs
1931*	WL	Aviators		1st	44	27	Art Griggs
1931**	WL	Aviators	-	2nd	48	31	Art Griggs
1932*	WL	Aviators	-	6th	33	37	Jimmy Patton
1932**	WL	Aviators		7th	30	49	Jimmy Patton
1933*	WL	Aviators		7th	6	12	Rube Marquard

Not in Professional Baseball

1950	WL	Indians St Louis (A)		4th	77	77	Joe Schultz
1951	WL	Indians Cleveland		3rd	84	68	Joe Schultz
1952	WL	Indians Cleveland		6th(t)	67	87	Ralph Winegarner
1953	WL	Indians St Louis (A)		8th	58	96	Mark Christman/ Herbert Brett
1954	WL	Indians Baltimore		6th	76	77	Lester Layton
1955	WL	Indians Baltimore		3rd	78	73	Buddy Bates
1956	AA	Braves Milwaukee		7th	65	88	George Selkirk
1957	AA	Braves Milwaukee		1st	93	61	Ben Geraghty
1958	AA	Braves Milwaukee		2nd	83	71	Ben Geraghty

Not in Professional Baseball

1970	AA	Aeros	Cleveland	4th	67	73	Ken Aspromonte
1971	AA	Aeros	Cleveland	3rd	66	74	Ken Aspromonte
1972	AA	Aeros	Chicago (N)	1st	87	53	Jim Marshall
1973	AA	Aeros	Chicago (N)	2nd	67	68	Jim Marshall
1974	AA	Aeros	Chicago (N)	5th	67	68	Mike Roarke
1975	AA	Aeros	Chicago (N)	5th	68	68	Mike Roarke
1976	AA	Aeros	Chicago (N)	7th	56	79	Doc Edwards
1977	AA	Aeros	Chicago (N)	4th	68	62	Harry Dunlop
1978	AA	Aeros	Chicago (N)	8th	58	77	Harry Dunlop
1979	AA	Aeros	Chicago (N)	8th	57	79	Jack Hiatt
1980	AA	Aeros	Chicago (N)	6th	61	74	Jack Hiatt
1981	AA	Aeros	Texas	6th	65	70	Rich Donelly
1982	AA	Aeros	Montreal	5th	70	67	Rich Donelly
1983	AA	Aeros	Montreal	5th	65	71	Felipe Alou
1984	AA	Aeros	Cincinnati	5th	78	77	Gene Dusan

Not in Professional Baseball

1987*	TL	Pilots	San Diego	1st	38	26	Steve Smith
1987**	TL	Pilots	San Diego	3rd	31	39	Steve Smith

1988*	TL	Pilots	San Diego	3rd	30	38	Pat Kelly
1988**	TL	Pilots	San Diego	4th	30	38	Pat Kelly
1989*	TL	Wranglers	San Diego	1st	37	33	Pat Kelly
1989**	TL	Wranglers	San Diego	1st	34	30	Pat Kelly
1990*	TL	Wranglers	San Diego	2nd	37	29	Steve Lubratich
1990**	TL	Wranglers	San Diego	3rd	29	38	Steve Lubratich
1991*	TL	Wranglers	San Diego	2nd	44	22	Steve Lubratich
1991**	TL	Wranglers	San Diego	3rd	32	35	Steve Lubratich
1992*	TL	Wranglers	San Diego	1st	39	29	Bruce Bochy
1992**	TL	Wranglers	San Diego	4th	31	37	Bruce Bochy
1993*	TL	Wranglers	San Diego	4th	28	34	Dave Trembley
1993**	TL	Wranglers	San Diego	2nd	37	31	Dave Trembley
1994*	TL	Wranglers	San Diego	4th	22	44	Keith Champion
1994**	TL	Wranglers	Texas	2nd	31	37	Keith Champion
1995*	TL	Wranglers	Royals	4th	31	37	Ron Johnson
1995**	TL	Wranglers	Royals	1st	41	27	Ron Johnson
1996*	TL	Wranglers	Royals	1st	38	30	Ron Johnson
1996**	TL	Wranglers	Royals	3rd	32	40	Ron Johnson
1997*	TL	Wranglers	Royals	4th	28	38	Ron Johnson
1998*	TL	Wranglers	Royals	4th	29	39	John Mizerock
1998**	TL	Wranglers	Royals	1st	46	26	John Mizerock
1999*	TL	Wranglers	Royals	1st	38	30	John Mizerock
1999**	TL	Wranglers	Royals	1st	45	27	John Mizerock
2000*	TL	Wranglers	Royals	2nd	34	33	Keith Brodie
2000**	TL	Wranglers	Royals	1st	43	27	Keith Brodie
2001*	TL	Wranglers	Royals	2nd	36	31	Keith Brodie
2001**	TL	Wranglers	Royals	1st	42	28	Keith Brodie
2002*	TL	Wranglers	Royals	2nd	34	35	Keith Brodie
2002**	TL	Wranglers	Royals	1st	42	28	Keith Brodie
2003*	TL	Wranglers	Royals	4th	31	39	Keith Brodie
2003**	TL	Wranglers	Royals	1st	40	30	Keith Brodie

* First half of split season ** Second half of split season

KSL-Kansas State League; WL-Western League, class A; WA-Western Association, class C; AA-American Association, class AAA; TL-Texas League class AA League classifications roughly reflect the size of the cities in each league—the greater the population, the higher the league is classified. The number of players, their salaries and professional experience are all limited by the league's class. At first, class A was the highest ranking minor league. In 1908 AA became the highest with the lowest being class D. In 1936, a rating called A1 was added between A and AA. The AAA classification was adopted in 1946 and by 1952 the Pacific Coast League was given the classification of "open", the highest ever for a minor league. In 1963, classes D, C, and B were abolished and replaced with Rookie Leagues. In addition to Rookie, today's system also includes A, AA, and AAA. However, A is divided between "slow" and "fast" classifications. From early in the 20th century until the 1930s, the farm system of optioning players from the majors to a minor league team or from a higher classified team to a lower classified one was prohibited—although at times winked at.